IMAGES
of America

PRESCOTT

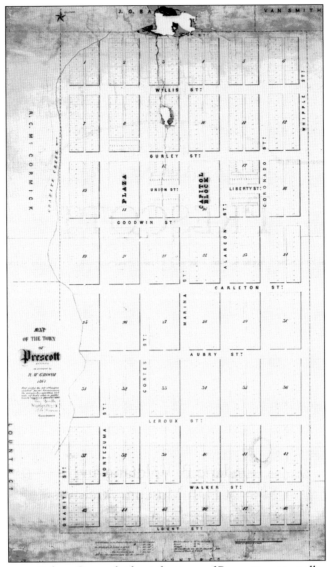

In 1864, town surveyor Robert Groom laid out the town of Prescott, supposedly using a frying pan as a transit. The streets of the town running north and south, other than Granite and Whipple Streets, were named after notables featured in Walter Hickling Prescott's book *History of the Conquest of Mexico*: Montezuma (Aztec leader), Cortez (Mexican conqueror), Marina (the female consort of Cortez), and Alarcon and Coronado (Spanish explorers). The streets running east and west, other than Leroux (Antoine Leroux, who accompanied Whipple west) and Aubrey (Francois Xavier Aubrey, early explorer and advisor to Whipple), were named after notables identified in the early history of Prescott: Sheldon, Willis, Gurley, Goodwin, Carleton, Walker, and Lount.

ON THE COVER: Bob Brow's famous Palace Saloon, pictured *c.* 1901, opened for business in September 1877. The carved mahogany back bar—rescued during the great fire of July 1900 by a team of cowboys and their horses—still serves customers today. After the fire, Brow partnered with Barney Smith (in the bowler hat at a gambling table), the owner of the former Cabinet Saloon next door, to rebuild the Palace in brick and native granite stone. Gambling was outlawed in Arizona in 1907.

IMAGES
of America

PRESCOTT

Frederic B. Wildfang and
Sharlot Hall Museum Archives

ARCADIA
PUBLISHING

Published by Arcadia Publishing
Charleston SC, Chicago IL, Portsmouth NH, San Francisco CA

Printed in the United States of America

Library of Congress Catalog Card Number: 2006926130

For all general information contact Arcadia Publishing at:
Telephone 843-853-2070
Fax 843-853-0044
E-mail sales@arcadiapublishing.com
For customer service and orders:
Toll-Free 1-888-313-2665

Visit us on the Internet at www.arcadiapublishing.com

To my daughter, Sarah Elizabeth Wildfang, who accompanied me on some of my first treks into the Yavapai wilderness.

CONTENTS

ACKNOWLEDGMENTS

I first came to Yavapai County, Arizona, from Kalamazoo, Michigan, in the fall of 1970. I had been to the West before, after graduating from high school in 1962 (fighting fires in John Day, Oregon) and after finishing a master's degree in 1968 (teaching high school English in Hilo, Hawaii). It wasn't until I got a job teaching at a boarding school on a ranch near Prescott, however, that I found my writer's "voice."

As an aspiring poet and instructor of "wilderness survival," I acquired a magical kinship with the high desert—the canyons and arroyos, the mountains and mesas—the territory first inhabited by the indigenous Yavapai Indians and later settled by the miners, ranchers, and entrepreneurs who made this part of the West famous. Now, after 30 years, I have been given the opportunity to recreate some of that magic and chronicle some of that famous history.

Thanks to my valuable research assistant, Lee Shoblom, founding director of the Lake Havasu Museum of History, Lake Havasu City; founding trustee of the London Bridge Museum, London; retired hall-of-fame broadcaster; and president of the Yavapai County Museum Alliance. And thanks to Mat Goin, the "computer nerd," who rescued me several times from the brink of disaster. And thanks to all the folks at the Sharlot Hall Museum—especially Richard S. Sims, director, who wrote the introduction and final chapter of this book; Ryan Flahive, archivist; Scott Anderson, assistant archivist, and Ron Ricklefs, photo digitizing—who provided both the photographs and the focus for this project. Unless otherwise noted, all of the images herein are credited to the Sharlot Hall Museum.

Most of the information in this book about the history of Prescott was synthesized from *Stories of Early Prescott* by D. E. Born, *Echoes of the Past: A Photographic Tour of 1916, Prescott, Arizona* by Nancy Burgess and Richard Williams, *Meeting the Four O'Clock Train and Other Stories* by Dixon Fagerberg Jr., *Founding a Wilderness Capital: Prescott, A. T.* by Pauline Henson, and *Prescott: A Pictorial History* by Melissa Ruffner. The rest was gleaned from the following publications: *We Call It 'Preskit'* by Jack August (*Arizona Highways*); *Joseph Reddeford Walker and the Arizona Adventure* by Daniel Ellis Conner; "Yavapai" by Sigrid Khera and Patricia S. Mariella (*Handbook to the North American Indians* by William C. Sturtevant, Ed.); *Arizona: A History* by Thomas E. Sheridan; and *Tales of Old Yavapai*, Vols. I and II, by The Yavapai Cowbelles of Arizona.

INTRODUCTION

This edition of the *Images of America* series explores the history of a mining camp that became a rough-hewn settlement that became a Victorian town that became one of the most desired places to live in today's New West. Prescott is emblematic of the transition from Old West to New West, evolving over the course of 15 decades from tobacco-chewing mountain hamlet to upscale retiree community. The history of Prescott is not unlike the history of other rural cities across America. First came the displacement, when the original settlers, the American Indians, were forced from their homelands. Second came the replacement, as the first European settlers and their military protectors took over croplands, woodlands, and hunting and fishing locales. Third came the investment capital (in western states almost all of it from eastern banks) that drove the economic engines of extraction, be it minerals extracted from the earth or vegetal protein extracted from the grasslands by cattle and sheep or trees extracted for construction of homes and businesses. The actual engines, the kind that roll down railroads, were the obvious physical force delivering capital, human and financial, and redistributing raw materials. Prescott witnessed all of this —the diminishment of native peoples, the establishment of a military post and a bustling territorial capital, the growing intensity of mining and ranching, the coming of the railroads, and the domination of the landscape by private and public entrepreneurs.

In Prescott today, as in the New West stretching from Jackson Hole to El Paso, real estate development is the most influential economy. This is nothing new. Manifest destiny itself may be viewed as a sort of divine realtor's license. Daniel Boone, critical historians maintain, was nothing more than a real estate speculator as he led his clients through Cumberland Gap. Lewis and Clark were not-so-secret agents of nation building and privatization of property. The Walker Party of 1863, the first white men to create a formal organization in Prescott, were gold-seeking transients, but within a year the town site was being platted and lots sold by the territorial government. The modern city government does not sell today's open ground, but open or occupied, acreage is being annexed as quickly as possible. The New West, like the Old West, needs a tax base. Other similarities include citizens who clamor for protection, for good roads, and for adequate water. A reporter in Colorado remarked to me over a cold beer that the most powerful groups in the West are the board members of irrigation districts. That thought might be modified to suppose that the most powerful groups in the Real Estate West are those who have the most convincing arguments about available acre-feet in hidden aquifers. The destiny of Prescott and environs, its limits of socioeconomic growth, will be made manifest by the limits on water consumption.

As the reader follows the chronology of Prescott history so adeptly laid out by Fred Wildfang, it should be kept in mind that water moves through all the stories and the photographs, then and now. In drought-slammed Arizona, where water flows uphill to money, the future of greater Prescott is in the hands of the sophisticated water dowsers, the land speculators who use hydrology reports and billboards rather than fruit-tree twigs. Prescott was a planned community from the get-go; it was designated the territorial capital from afar, by Mr. Lincoln himself, who was preoccupied with a nation torn asunder. Prescott remains a planned community, but now segmented into many

communities, many of them replacing former ranches, and now gated. Like many "last best places" to buy that last mansion or seasonal manse, Prescott has all the chi-chi to satisfy the newcomer, but holds on to, with no small effort, its authenticity. Will that authenticity, so important to the tourism economy here, remain important to residents? Will Prescott, with the unctuous slogan of "Everybody's Hometown," become nobody's in particular? Getting those answers is the work of historians and readers of history. For the just-the-facts historical perspective it delivers, you have the worth of this book.

—Richard S. Sims, Director
Sharlot Hall Museum

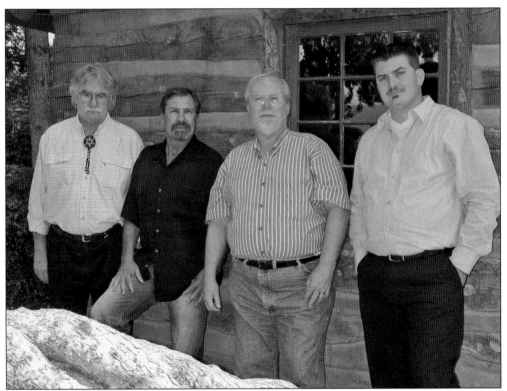

Museum director Richards S. Sims, author Frederic B. Wildfang, assistant archivist Scott Anderson, and archivist Ryan Flahive pose on the heritage campus of Sharlot Hall Museum. All of the historical images in this book came from the Archives of Sharlot Hall Museum, a full-service research facility. The Archives serves 3,500 patrons annually, from academic scholars and local historians to student researchers and genealogists. The archives facility at Sharlot Hall Museum is not a typical research library; it specializes in connecting people to the past, interpreting stories of the structures and objects of the museum with archival evidence of their existence, including historical maps and drawings, literary and historical manuscripts, dairies and journals, photographs, newspapers, and a library. The Archives provides a truly unique research experience for both experienced and novice researchers yearning for knowledge. Modern, state-of-the-art photographic exhibits grace the Archives entryway, and the Archives is surrounded by one of the paramount museum settings in all of Arizona. A treasure of Arizona history, the Sharlot Hall Museum Archives strives to convey the historical importance of the central Arizona highlands to Arizona's ever-growing communities and Western heritage.

One

THE YAVAPAI

Although the Yavapai are made up of several different groups occupying what is today central Arizona, they consider themselves one people, originating in the Sedona Red Rock country. Their language is an Upland Yuman dialect, related to the nearby Hualapai and Havasupai. One of these groups, called the "Yevepe" or "Yavapai," occupies the area around what is known today as the town of Prescott.

Despite the fact that they come from different linguistic stocks, the Yavapai often have been confused with the Apache. This mistaken identity could be due, as some have suggested, to Apache influences upon the Yavapai. Another reason for this confusion, however, may be simply the similar nature of both their hunting-gathering cultures.

Until gold was discovered in central Arizona, the Yavapais had little contact with Anglo-Americans. But after Anglo encroachments upon their homelands, relations became uneasy. In 1863, after the Arizona Territory was created, Fort Whipple was established at Del Rio Springs in Chino Valley and stocked with cavalry to protect the Anglos from the Indians.

Nevertheless, the Native American attacks continued—some of them notorious for their mutilations—spurring the establishment of the Rio Verde Reservation, near what is now Camp Verde, in 1871, and an executive order from Gen. George Crook that all "roving Apache" be secured on this reservation or be treated as hostile.

By 1873, most Yavapai had been forced onto the Rio Verde Reservation and were making out quite well, supporting themselves by farming in the valley, but then were ordered south to share the Apache reservation at San Carlos near present-day Globe. Some Yavapai escaped and managed to stay behind, working for the Anglos on farms, ranches, mines, smelters, road construction, or as domestic servants.

After the turn of the century, the Yavapai were allowed to return to the homelands. Those who came back to the Prescott area settled near the abandoned Fort Whipple and continued to seek jobs among the Anglos.

Ultimately, in 1935, 75 acres from Fort Whipple were designated as a reservation for the Prescott Yavapai. In 1956, another 1,320 acres were added to the reservation, so that it now surrounds the city of Prescott on three sides.

Today, even though their population has dwindled to some 160 members, the Prescott Yavapai are flourishing. Ironically, with the addition of their new shopping center, casino, 160-room hotel, and convention center, the Yavapai Prescott Indian Reservation is one of the largest employers in the area.

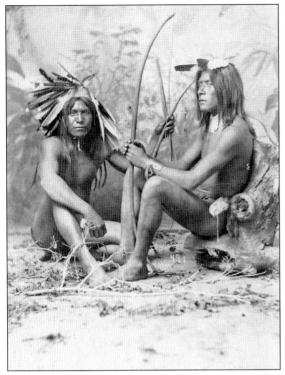

Yavapai men in the hunting-gathering tradition hunted game with bows and arrows, clubs, throwing sticks, snares, and traps. Men, women, and children participated in group drives of rabbits. Everyone collected lizards, locusts, grasshoppers, and caterpillars at will. Yavapai women gathered and processed nuts, seeds, berries, fruits, roots, and greens depending upon the seasons.

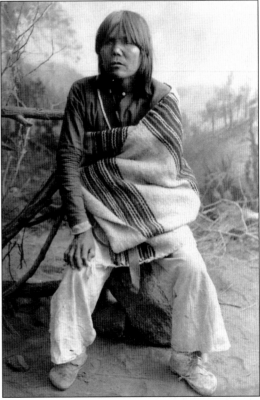

In summer, men wore breechclouts and moccasins. Women wore apron-style tops and long breechclouts, draped in front and back, and long-legged moccasins; after Anglo contact, they wore skirt-and-blouse combinations. In winter, rabbit-fur ponchos and leggings were added to both their outfits. Both men and woman wore their hair in bangs, and both adorned themselves in beads and necklaces, bracelets, ear and nose rings. They painted themselves with red clay to be fashionable and to protect themselves from the sun.

Yavapai baskets, used for winnowing, carrying, cooking, and storing, were of the highest quality. Seeds and nuts, ground up with mortars in *metates*, were stored in woven baskets or earthen pots and cached underground or in caves. Foods that needed to be cooked were either roasted or boiled in clay pots or baskets. Not only practical but also decorative, Yavapai coiled and woven baskets were valuable trade items.

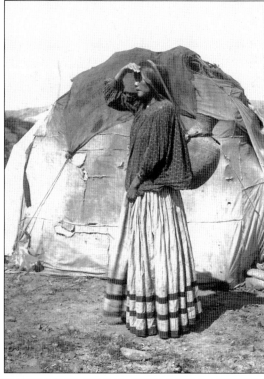

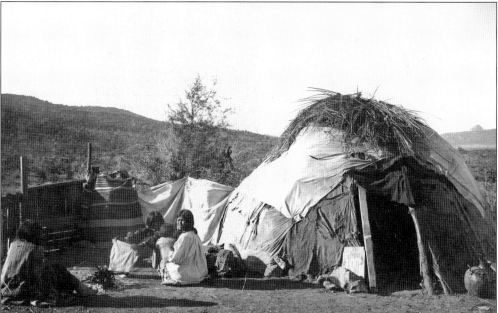

During the gathering seasons, the Yavapai lived in brush huts called "*whas.*" During the winter, they resided in more permanent dome-shaped thatched houses called "*whambunias,*" which were reinforced by mud plaster and often covered with skins. Wherever water was available, the Yavapai were more sedentary and practiced agriculture, planting and harvesting corn, beans, squash, and tobacco.

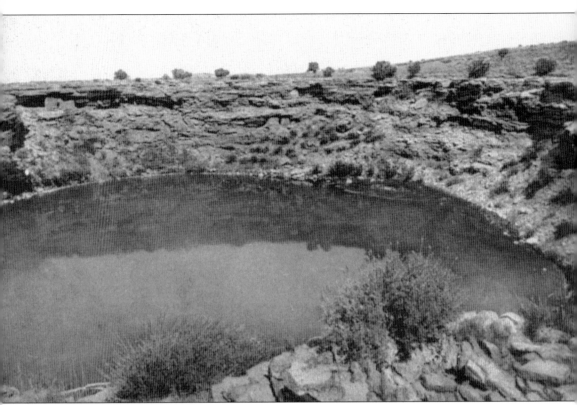

After the coming of the Anglo settlers and the resulting destruction of Yavapai hunting-and-gathering areas, Indian attacks, such as the one described below by D. E. Born in *Stories of Early Prescott*, became more frequent:

> In August of 1872 Joseph Burroughs was helping Wales Arnold get in a crop of hay on his ranch on Beaver Creek near Montezuma's Well. . . . The other two men were taking a load of hay from the field leaving Arnold and Burroughs alone raking the hay into piles when they were attacked by Indians. . . . Joseph Burroughs was killed with the attack. Once the farmers began to return the fire the attack ended and the Indians left. All but the two that had been killed in the fight.

Often these attacks were in retaliation for Anglo interference and disruption of the Yavapai culture. According to Yavapai creation stories, for instance, Montezuma's Well, pictured here, is considered the exact spot where all beings in this world emerged from the underground world by climbing up stalks of plants through a hole in the earth. This place of emergence, Montezuma's Well, is still considered to be holy.

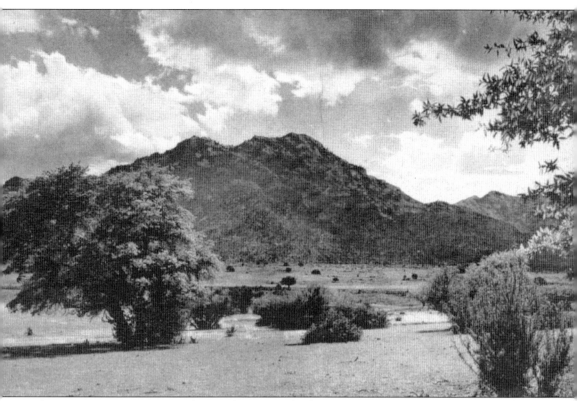

This is Granite Mountain, northwest of Prescott, which is another Yavapai sacred site. Even today, the violation of such sacred sites provokes a lingering ill feeling among the Yavapai. Another holy site, the cave of First Woman in Boynton Canyon in the Sedona Red Rock Mountains, has been blocked by recent real estate developments. Having to endure the continuous exploitation of their lands, resulting in the destruction of their sacred sites as well as the depletion of the indigenous flora and fauna they depended on for survival, makes it no surprise that the Yavapai began fighting back.

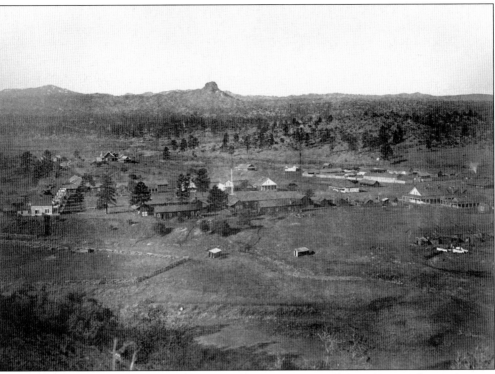

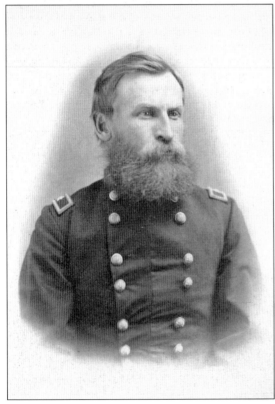

In September 1863, in order to protect miners and settlers from the Indians, Capt. Nathaniel J. Pishon and Surveyor General John A. Clark set out from Santa Fe, New Mexico, along Whipple's route into the new Territory of Arizona to establish a military post there. Cutting southwest into the territory from the San Francisco Peaks, Pishon and Clark founded Fort Whipple at Del Rio Springs, the headwaters of the Verde River, where there was good natural pasture for the horses and good water. In June 1864, Fort Whipple (above, 1870s) was moved to its present site on Granite Creek just north of the town of Prescott. In 1870, Gen. George Stoneman assumed command. But in 1871, Indian problems became more intense and Gen. George Crook (left) took over.

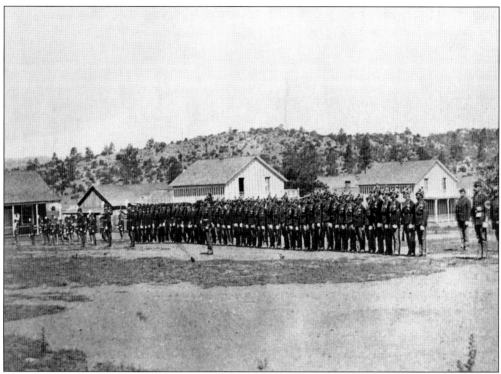

With the help of Apache and Pima scouts, Crook's men (above) were able to subdue the Yavapai, Hualapai, and Western Apache in the area, bringing peace to Prescott and making the general a local hero. By 1873, most of the Yavapai had been corralled onto the Rio Verde Reservation at Camp Verde (below, c. 1890) in the middle Verde Valley. Despite the adverse conditions on the reservation, including malaria, the Yavapai were able to survive by farming, irrigating, and raising crops by hand, until 1875, when they were moved to the Apache reservation at Camp San Carlos. General Crook protested this move and assured the Yavapai that they would be able to return to their homelands after they learned the white man's ways. Nevertheless the Yavapai were marched 180 miles south to San Carlos.

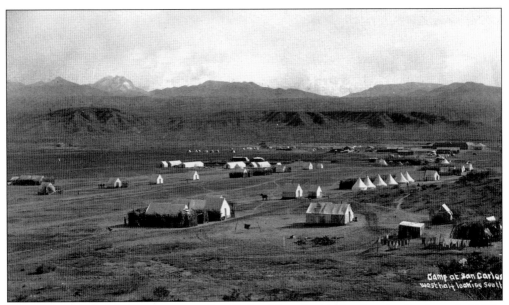

The Yavapai shared the reservation at San Carlos (above) with the Apache. In the early 1900s, the Yavapai gradually returned to their homelands but were forced to make a living by working on farms and ranches, mines and smelters, and in general construction. Yavapai women, such as Viola Jimulla (below, 1970) worked as domestic servants for Anglo families.

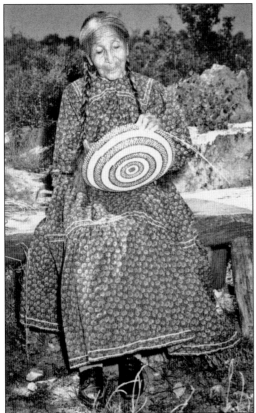

After her husband Sam Jimulla's death in 1940, Viola Jimulla (at left) became the principle chieftess of the Prescott Yavapai. Traditional leadership in the community, a form of government consisting of a chief and a group of councilors made up of family heads, continued to be passed down in this family until 1962. From then on, a board of directors was organized with a president, vice president, secretary-treasurer, and two board members elected every two years.

Two

EARLY EXPLORERS, MINERS, AND SETTLERS

Ewing Young was probably the first Anglo-American to penetrate the wilderness that is now Yavapai County. Accompanied by Kit Carson, Young supposedly followed the Verde River north to its headwaters in 1829.

This was before the Mexican War in 1848, when what is now Arizona was still part of Mexico. After Arizona was ceded to the United States as part of the New Mexico Territory and gold was discovered in California, the U.S. government began sending military parties west to find a land route across the country.

Although it is reported that Capt. John Swilling led a campaign into the Yavapai County area from the south in 1860, the first verifiable exploration of the Prescott area was conducted by Joseph Reddeford Walker in May 1863. Leading a party of some 30 prospectors, including Jacob and Samuel Miller, James Sheldon, John Dickson, and King Woolsey, Walker discovered gold on the headwaters of the Hassayampa River, breaching the Bradshaw Mountains about seven miles south of present-day Prescott. Later the Walker party moved to "Walker Gulch" on Lynx Creek, joining Jacob and Samuel Miller and others who had established a settlement there.

In June 1863, a party from California, led by Paulino Weaver and A. H. Peeples, filed another group of claims on Antelope Creek about 30 miles south of Prescott. Other early claims were recorded on the Agua Fria by John Dickson and King Woolsey and on Groom Creek by Robert Groom. James Sheldon, who had come to Arizona with Walker, filed a claim on Granite Creek, north of the Walker camp, at a ranch he reportedly shared with John Forbes and Van C. Smith. George Lount, who had come from San Francisco shortly after Walker, filed a claim on Granite Creek even further north of the Walker camp, apparently close to the site where Prescott is now situated.

By December 1863, Paulino Weaver had a camp on Granite Creek in the area of Prescott proper. Soon after, George Lount, Hezekiah Brooks, Hiram Coye, A. E. Noyes, J. G. Barney, and Van C. Smith claimed land there as well. By March 1864, several buildings occupied the site, including the store of Manuel Yseria.

Most significantly, though, on April 28, 1864, the secretary of state for the new territory of Arizona, Richard C. McCormick, claimed land on the west side of Granite Creek just opposite of the present site of downtown Prescott, where later the log structure that became the home of the first territorial governor was built.

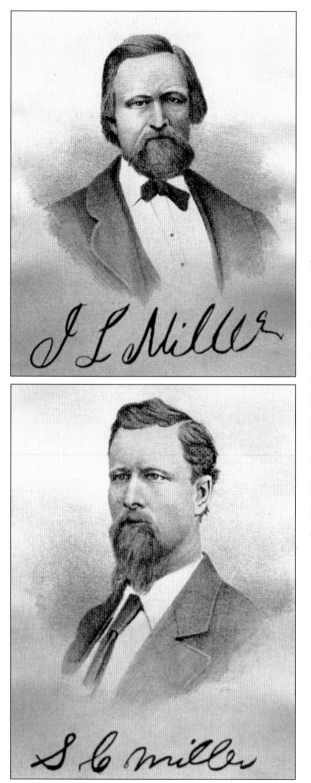

Jacob L. Miller (above left) and Samuel C. Miller (below left) were members of the Walker party when gold was discovered on the Hassayampa River in May 1863. Walker was a rugged mountain man and prospector who had been scouring parts of New Mexico, Arizona, and California for years. In 1820, he had emigrated from Missouri to New Mexico and helped establish the beginnings of the Santa Fe Trail. In 1833, he pushed on to California, crossing the Sierras and camping in Yosemite, and in the 1840s led the first wagon train from St. Louis to California. Acting as a guide for John C. Fremont, Walker also explored the Salmon, Snake, Colorado, and Virgin Rivers.

Also making the trip with Walker was King S. Woolsey, pictured here around the 1870s. As stated below by Daniel Ellis Conner in *Joseph Reddeford Walker and the Arizona Adventure*, the trip wasn't easy:

> Day by day we continued our journey up this stream bed which I thought in my soul was the roughest country of ordinary mountains and hills that I had yet seen in all my Rocky Mountain experiences. The creek was a narrow gorge-like canyon that could not be traced with any degree of certainty as to its general course. . . . On one occasion in descending one of those steep hillsides, the crupper of Captain Walker's saddle gave way and tossed him over the mule's head down the hill, where he landed upon his shoulders into a bunch of prickly pear bushes.

The spot where Walker first made camp, near the junction of the Hassayampa and Groom Creek, was soon the nexus of several mining claims, some of which are still located in the general area today. By August 1863, however, when John Clark made an inspection of the gold fields in the Prescott area, Walker had moved to "Walker Gulch" on Lynx Creek, later called the town of Walker (pictured here at the turn of the century), joining Jacob and Samuel Miller, George Coulter, H. B. Cummings, Frank Finney, and others who had established a settlement there.

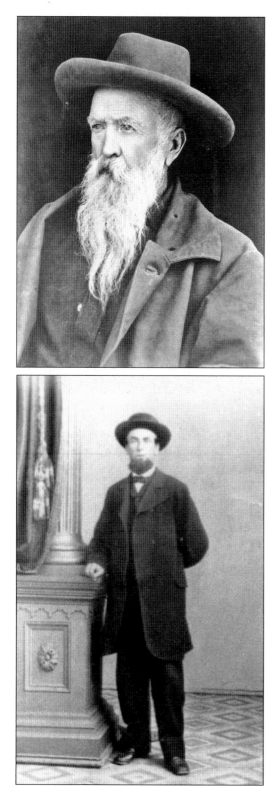

Among other early claims, George Leihy had a camp in Copper Basin, southwest of Prescott; John Dickson and King Woolsey had two quarter sections on the Agua Fria; and Robert Groom (above left, 1870s) had a claim on Groom Creek, a tributary of the Hassayampa. James Sheldon had a claim up Granite Creek that was eventually occupied by what was described in Pauline Henson's *Founding a Wilderness Capital* as a a large and roomy log cabin "with a grand large fireplace, one table, two rough beds, and some seats. . . . Saddles, bridles, rifles, pistols and venison were hung all over the walls, inside and out. There was no window, the door and the chimney letting in enough daylight." George Lount (below left, c. 1870) had a claim even further up Granite Creek, the "Black Lode," in the general vicinity of the future town site of Prescott.

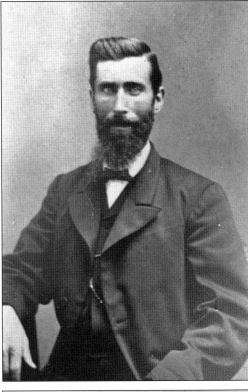

By December 1863, the Prescott town site, originally referred to as Granite City or Goodwin, was starting to gain in population. Paulino Weaver, said to be the first citizen of Prescott, had his cabin there. George Lount and Hezekiah Brooks (above right) claimed a quarter section each on the southern boundary of the town. Hiram Coye and Alfred Osgood Noyes (below right, 1880s) claimed parcels adjoining them. J. G. Barney and Van C. Smith owned a quarter section each on the northern boundary of town. In February 1864, according to Pauline Henson in *Founding a Wilderness Capital*, it was reported, "Three or four men here were living in their wagon bodies" in the general vicinity of the Prescott town site and at least one "log cabin was quite finished."

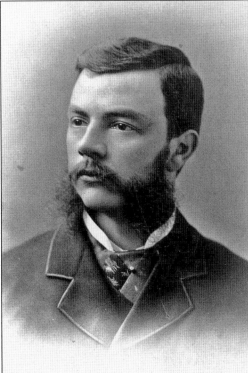

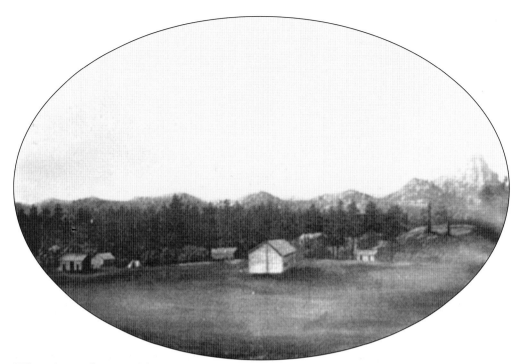

When the resolutions of the Quartz Mountain District were published later on March 30, 1864, it is affirmed in Pauline Henson's *Founding a Wilderness Capital* that already "several stores are erected" in the general vicinity of Prescott (above, *c.* 1864) and "there are indications of enterprise on the part of the proprietors of the place." Several trading posts were said to be there. Manuel Yrissari, a merchant from New Mexico, had his store there (below, 1910). Other merchants and traders from New Mexico had establishments there and Mexicans from "Old Mexico" bought lots there. Also it is quite certain that Dr. Charles Leib, a former surgeon at the newly established Fort Whipple 30 miles south of Prescott, had moved there as well.

Three

FORT WHIPPLE AND THE TERRITORIAL CAPITAL

On February 4, 1863, President Lincoln created the Territory of Arizona. John A. Gurley was appointed governor, Richard C. McCormick secretary of state, and John Noble Goodwin chief justice. But before the officials could leave for Arizona in order to establish a new capital there, Gurley became ill and died, leaving Goodwin to be appointed governor and William F. Turner to take his place as chief justice.

Gen. James H. Carleton, commander of the military in the Territory of New Mexico, was charged with locating a military post in the new Territory of Arizona. On December 23, 1863, Fort Whipple was established at Del Rio and readied for the arrival of the governor's party on January 22, 1864. In June 1864, a new site for Fort Whipple was located 30 miles south of Chino Valley on the headwaters of Granite Creek near the site chosen for the new capital, now known as the town of Prescott.

Robert Groom was hired to survey the new town and the site for the governor's mansion. By September, there were six rooms finished on the first floor of the mansion, including the governor's office, where it is thought that the first legislature of the territory met on September 26, 1864. The first legislature adjourned on November 10, 1864.

Meanwhile the town of Prescott was growing. The first lot sales on June 4, 1864, totaled 73. By July 1864, a dozen houses and stores were being built, including several on the Plaza, such as the store of Gray and Company of La Paz, William J. Berry's gun shop, the store of Barth and Barnett, A. Wertheimer's store, John Dickson's hotel and billiard saloon, another saloon run by a Mr. Roundtree, the hotel of a Mr. Jackson, and George Barnard's restaurant, the Juniper House. By the spring of 1865, some 50 or 60 structures had been built in town.

In 1867, the capital of Arizona was moved from Prescott to Tucson, returned to Prescott in 1887, and moved permanently to Phoenix in 1889. In 1897, Fort Whipple was deactivated as a military post and headquarters were moved to Los Angeles. After that, it was reactivated and deactivated a couple of times until, in 1918, it became an army hospital that was noted as one of the best tuberculosis facilities in the country. In 1931, Fort Whipple ended up in the hands of the Veteran's Affairs Administration and is still operated as a medical-center complex for veterans today.

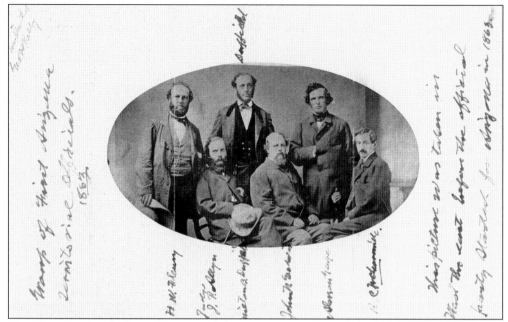

The first officials of the new Territory of Arizona, pictured here from left to right, include (first row) Associate Justice Joseph P. Allyn, Gov. John Noble Goodwin, and Secretary of State Richard Cunningham McCormick; (second row) the governor's personal secretary, Henry Waring Fleury, U.S. marshall Milton B. Duffield, and Attorney General Almon P. Gage.

William T. Howell, pictured here around the 1860s, was also appointed associate justice in the new territorial government. Justice Howell sponsored the most important bill passed in the first territorial legislature, a code of laws for Arizona that remained on the books until revised in 1877 called the "Howell Code."

This image is of Charles D. Poston around 1870. He was appointed superintendent of Indian Affairs. Levi Bashford was appointed to the newly created office of general surveyor. Bashford became a prominent citizen in the town of Prescott, building the first courthouse in 1867. It was a two-story affair on North Cortez Street with the jail and sheriff's office on the first floor and a courtroom on the second. Bashford also founded the Bashford Mercantile Company in 1868.

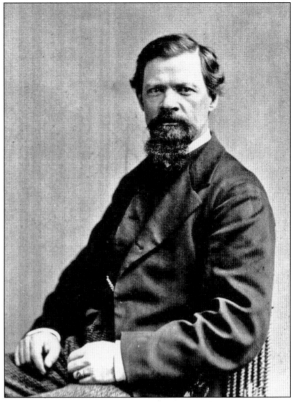

In order to provide a headquarters for the new government, Capt. Nathaniel Pishon and Gen. John Clark, pictured here around the 1860s, established Fort Whipple at Del Rio Springs in Chino Valley. In June 1864, however, after a difficult exploration of the northern portion of the territory, the fort was moved south to its present location near the town of Prescott so as to better protect the miners and settlers there.

Shortly after Fort Whipple moved to its new location, work began on the governor's mansion, pictured here c. 1885, on the Pinal Ranch property west of Granite Creek that recently had been purchased by Secretary McCormick. The log structure consisted of six rooms on the first floor that included the governor's office, the largest of the front rooms downstairs, in the north wing of the mansion. There was a large room upstairs as well, accessed by ladder, which was used by the official party as a communal bedroom. For the first few months after arriving in Prescott, Maj. Edward B. Willis, the commander of the troops at Fort Whipple, was stationed in the governor's mansion. Whether or not the first meeting of the legislature met at the governor's mansion, or at the building on Gurley Street constructed for that purpose by Van C. Smith, is debatable. Notwithstanding that fact, George W. Leihy, King Woolsey, and Robert Groom were among the members of the council at that first meeting on September 26, 1864. Dr. James Garvin was elected to the House of Representatives. William Claude Jones was elected speaker of the house and Coles Bashford president of the council.

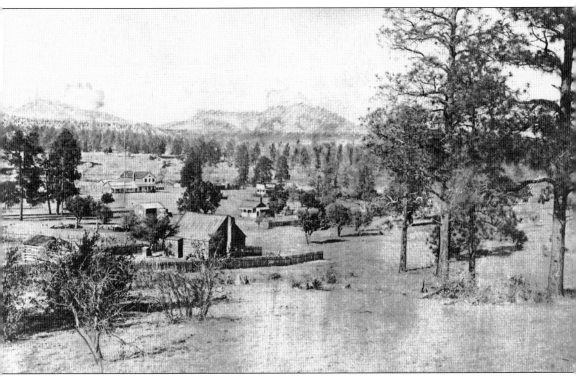

In the meantime, back in May 1864, a community meeting was held at the store of Manuel Yrissari, called "Fort Misery" and said to be the first public building in Prescott, to appoint a committee to lay out the town site, pictured here around the 1870s. Van Smith, Robert Groom, the town surveyor, and Hezekiah Brooks, the first probate judge of Yavapai County, were named the first township commissioners. The best mode for the dispersal of lots in the new town was determined at that meeting. It was also decided that the town would be named after Walter Hickling Prescott, author of the popular *History of the Conquest of Mexico*. It was thought at the time, erroneously, that central Arizona was the original dwelling place of the ancient Toltecs and Aztecs.

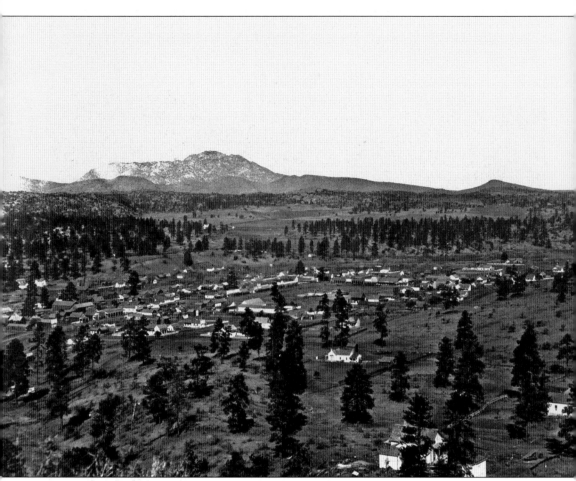

According to the *Arizona Miner* in July, 1864, which Pauline Henson mentions in her *Founding a Wilderness Capital*:

> The spot chosen and surveyed for the town embraces a beautiful mesa of two quarter sections of land upon Granite Creek, running with the same for a mile. . . . The land reserved for the public buildings . . . is an entire square, situated on the highest point, from which a grand view of the surrounding country can be had. The square is directly connected with the plaza by a street called Union Street, which . . . runs through the centre of the only intervening square.

Already businesses were springing up (above, 1870s). The *Arizona Miner* moved to Granite Street on the west side of Granite Creek. Soon after, the blacksmith shop of Gabriel Savedra and William Skillicorn opened also on the west side of Granite Creek. Other businesses were opening on the east side, particularly around the new Plaza. Notable were the offices of Dr. James Garvin and Dr. T. P. Seeley; the offices of the assayer Charles Borger; George Barnard's restaurant, The Juniper; and Isaac Goldberg's Quartz Rock Saloon.

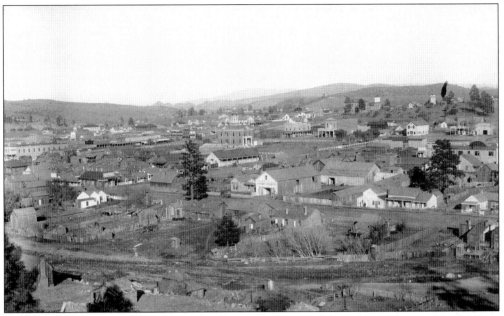

By the mid-1870s, the founding fathers had begun businesses of their own in Prescott. A. O. Noyes and George Lount had the first sawmill in Arizona, the Pioneer Sawmill, which ultimately became the Clark and Adams lumberyard. The Miller brothers started the first freight company in the area, moving the territorial government back and forth between Prescott, Tucson, and Phoenix. Hezekiah Brooks began a flour business with Charles Hayden of Tempe.

John H. Dickson and Mary Jane Ehle (at right) were married at the governor's mansion on November 17, 1864, the first marriage recorded in Prescott. John Dickson was one of the original Walker-party "Argonauts." Mary Ehle was the daughter of Joseph and Margaret Ehle, early farmers in the area who were known for their honeybees and Spanish chickens. The Ehles also owned the Montezuma Hotel on the corner of Montezuma and Willis Streets.

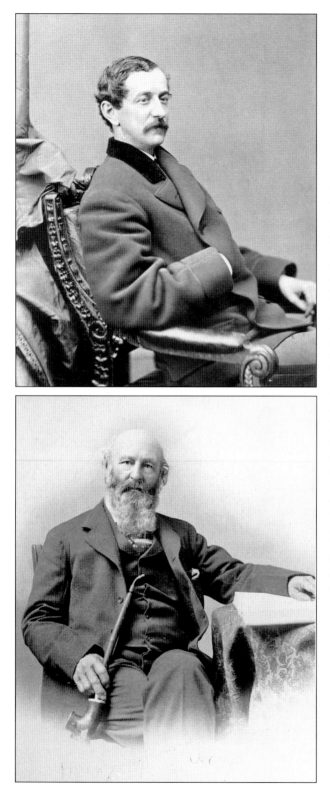

In 1867, when the Fourth Territorial Legislative Assembly moved the capital of Arizona from Prescott to Tucson, the governor's mansion on Granite Creek was abandoned by the territory's second governor, Richard C. McCormick, and left in the care of Henry W. Fleury. McCormick (above left, c. 1870) served as governor until 1869 and then became a delegate to the U.S. Congress. Fleury (below left, 1880s) succeeded Hezekiah Brooks as probate judge for the county in 1870 and held his court in the former office of the governor. In 1877, the capital was returned to Prescott and remained there until 1889, when it was permanently moved to Phoenix, but by that time the Congregational Church owned the governor's mansion. Ultimately the governor's mansion was purchased by the State of Arizona and became part of the Sharlot Hall Museum.

Four

MINING IN THE AREA

After the discovery of gold on the Hassayampa, Lynx, and Antelope Creeks in 1863, some 400 or 500 miners were working placer mines there. New placer operations were also being opened up on Big Bug Creek, Turkey Creek, and the new Bradshaw district in the mountains.

Unfortunately the early discoveries didn't turn out to be as rich as expected, and transporting ore over long distances to be smelted made mining even less lucrative. Accordingly stamp mills and smelters were brought into the county with the first stamp mill at the Vulture Mine, south of Prescott near Wickenburg, and other stamp mills closer to Prescott, such as King Woolsey's water-powered mill on the Agua Fria. Early in 1880, C. P. Dake bought the Thunderbolt Mill on Lynx Creek and built a smelter there. By the turn of the century, up to $2 million of gold was being produced in Yavapai County annually.

With the discovery of rich silver lodes in the Bradshaws came several new mines, notably the Senator, Congress, and Blue Bell Mines. One of the most interesting discoveries was Frank Doggett's Amulet Mine. In 1886, while prospecting on Lynx Creek, Dogget accidentally dropped his pick on his foot, got mad, and buried the pick into the ground as hard as could. Retrieving it later, he found the pick stuck into a rock that looked like a chunk of silver. The rock and other samples he collected assayed out at $285 per ton in silver and $80 per ton in gold.

Ultimately the gold and silver mines played out, and copper became king. First there were discoveries southwest of Prescott in the Black Rock District and Copper Basin. Then, in the 1880s, came the mines east of Prescott, including those at Stoddard, Copper Mountain, and Poland.

The most productive copper mine was the United Verde Mine in Jerome, producing close to $30 million in 1929. The first claims in Jerome were purchased by Gov. Frederick A. Tritle and organized under the auspices of United Verde Copper Company in 1883. In 1900, the Little Daisy Mine in nearby Clemenceau became the United Verde Extension (UVX). In 1935, the Phelps-Dodge Corporation purchased the United Verde and the UVX, clearing more than $20 million by 1950.

After closure of the United Verde in 1953, the Iron King at Humboldt (which operated from 1934 until 1967) and the Cyprus Bagdad Copper Company southwest of Prescott (still operating today) were virtually the only paying mine operations in Yavapai County.

At first, the placer operations in Yavapai County (as documented in this photograph on the Hassayampa) were quite simple. As Judge Joseph Allyn described the process in 1864, recounted in Pauline Henson's *Founding a Wilderness Capital*:

> Great square holes or shafts are sunk in or near the bed of the creek where there is water, ultimately down to the bedrock, and the miner is at work breaking the rock and throwing up the dirt from the bottom to where the rocker is; the rocker is a succession of sieves or boxes on rockers; the original dirt is thrown on top and the earth and dust works through and falls on to another sieve, where it is still separated; finally the black sand plentifully sparkling with yellow is thrown into a pan. It is quite a matter of dexterity to work out a pan of earth; you dip it into water and keep shaking it so that the particles may be separated and the gold by its specific gravity sinks to the bottom.

Later the gold placers east of Prescott, like this one on Big Bug Creek near Mayer pictured in 1872, were being dredged hydraulically.

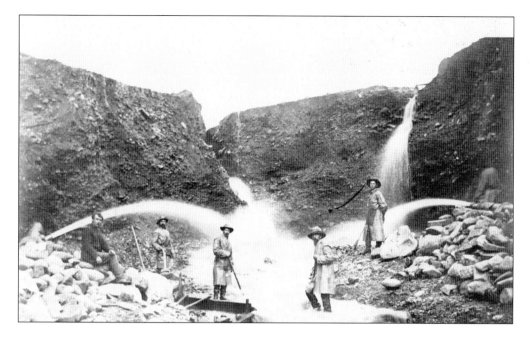

The gold placer on Lynx Creek near Dewey (above, 1890) was also later dredged hydraulically. Moreover, according to Pauline Henson in *Founding a Wilderness Capital,* new discoveries like the Hassayampa (below, 1890s), the Benedict, Chase, Albany, Native American, Julia, and McDougal Mines were being "pronounced by the assayers at the mint at San Francisco as . . . up to the standard of first-class ledges."

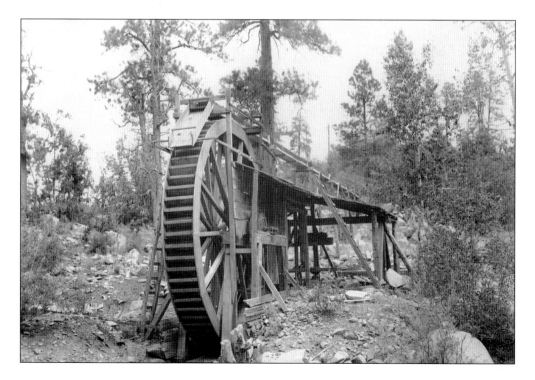

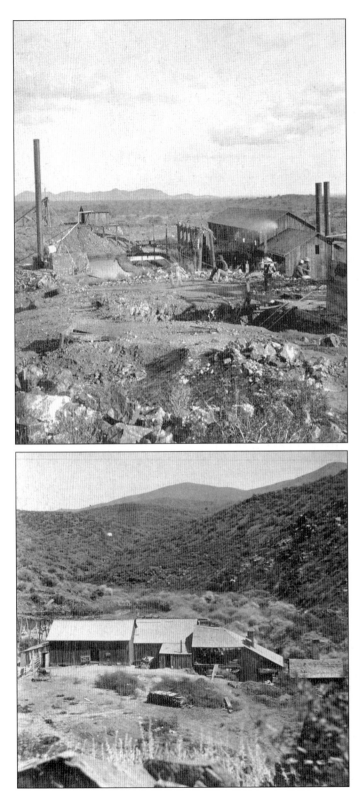

By 1864, the Vulture Mine (above left, c. 1890) was producing as much as $700 per day. In addition to the mills east of Prescott that included the water-powered mill on the Agua Fria (below left, 1878), the two-stamp mill on Lynx Creek, the 20-stamp mill on Turkey Creek, and the Dake smelter on Lynx Creek, a 40-ton smelter was constructed by John Howell on Big Bug Creek, near the Dake smelter, in 1882. The Howell smelter, however, along with the town of Howell that had sprung up around it, closed down shortly later. After going bankrupt and having the property seized and put up for auction—only to be bought back by John Howell himself at a greatly reduced price—financier Morris Goldwater had to write off a $5,000 debt.

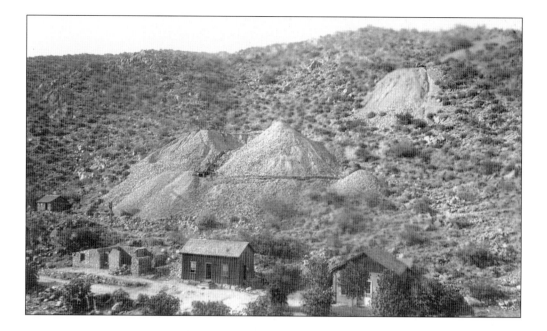

With the cost of smelting ore reduced, the mines were back in business. And with the mining of silver taking over for gold and the mountains being renamed the "Silver Bradshaws," several new mines came into existence, among them the Tip Top (above, 1930s) and Tiger (below).

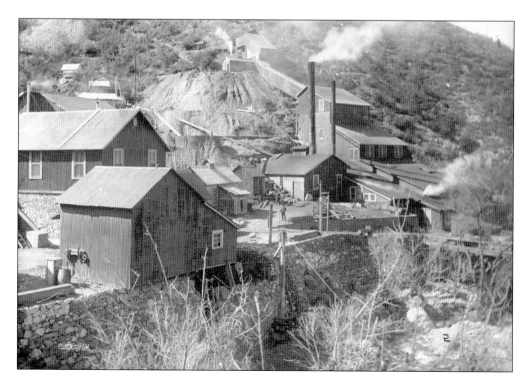

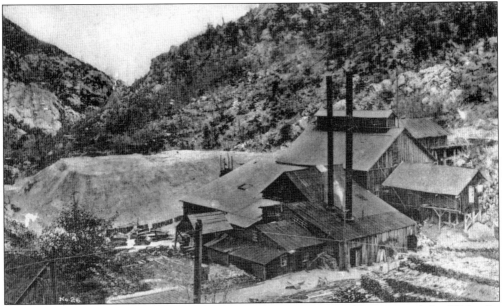

Other mines were also established, including Crown King, pictured here around the 1890s, the Home Run, Prince Albert, Chicago, Webfoot, Empire, and the famous Senator, which has been producing gold, silver, and copper since 1878.

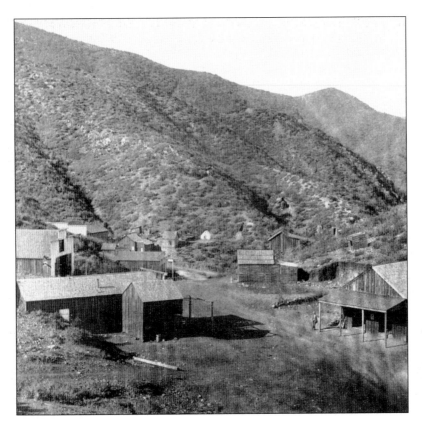

The Peck was among the most notable silver mines in the Bradshaws in the 1880s.

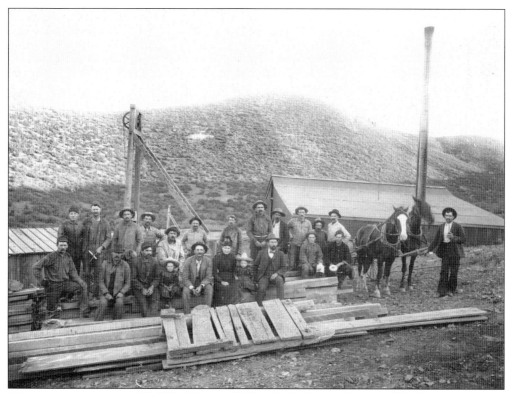

Also important were the McCabe (above, 1910) and the Octave (below, 1890s).

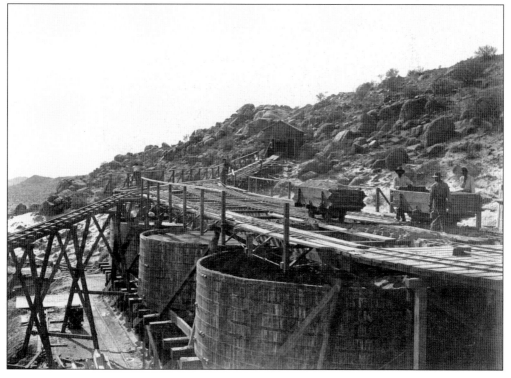

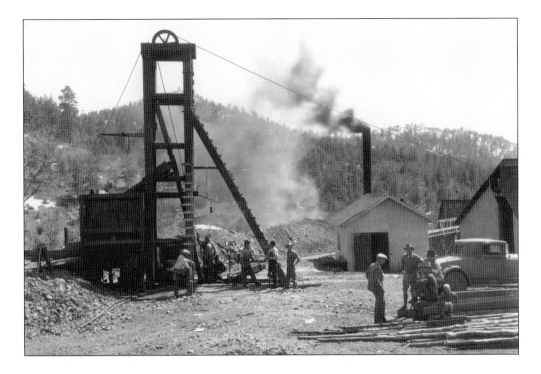

Midnight Test (above, *c.* 1930), Monte Cristo (below), the Gold Basis, the Cash, the Storm Cloud, the Independent, the Blue Dick, the Silver Flake, and the Silver King were also among the most notable silver mines in the Bradshaws during this period.

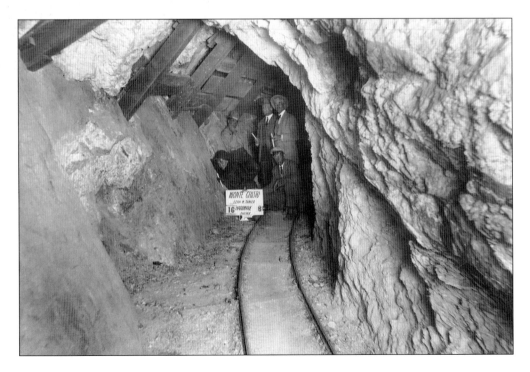

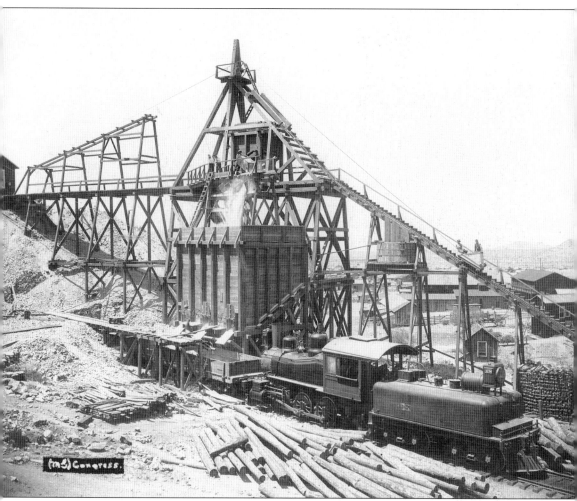

In 1884, the Congress Mine, pictured here around 1900, was purchased from J. W. Dougherty and J. W. McGowan by Joseph "Diamond Joe" Reynolds for $60,000. Frank M. Murphy was named superintendent. A mill was built, and the town of Congress came into existence. The upper town consisted of the mill, the company offices, the company store, the hospital, and the residential section, and the lower section housed the various businesses. The Congress eventually produced over $1 million in silver.

In 1894, Frank M. Murphy (second from left), sitting here with "Diamond Joe" Reynolds (left), formed a partnership with E. B. Gage, N. D. Fairbank, and Wallace Fairbank to purchase the Congress from the estate of Reynolds. They had a railroad line run from Martinez, now known as Congress Junction, to the Congress Mine.

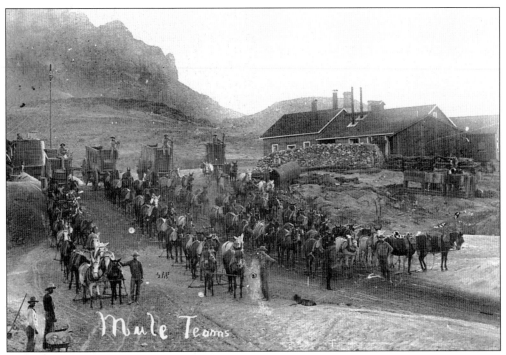

With the advent of the railroad, ore from the mines and supplies to the mines were, of course, easier to ship. No longer did the business have to rely on mule trains, as pictured here at the Silver King. Even as late as 1893, the first copper strikes in Jerome were also hauled out by mule.

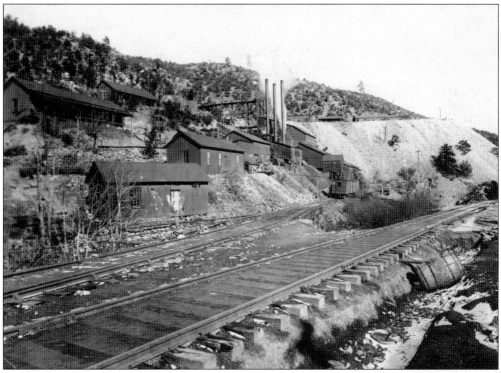

Railroad spur lines from Prescott were constructed to Jerome via Chino Valley in 1894 and to the mines in the Bradshaws, reaching Poland Junction in 1902 and Crown King in 1904. A line from Poland Junction to Poland itself, called the Bradshaw Mountain Railroad and headed up by Frank Murphy, was completed in 1905 (above). Among the several mines serviced by the mill at Poland—including the Hamilton, the richest one, owned by E. B. Gage and Frank Murphy—were the mines at Walker, just over the mountain from Poland. By 1906, an 8,000-foot tunnel had been dug to connect the two (right).

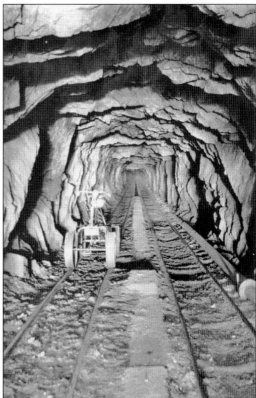

After copper was discovered in Yavapai County at Copper Mountain, Poland, and Stoddard, copper mills and smelters were put into production. Ore from the mines east of Prescott, including the Blue Bell and Desoto, were processed at the Humboldt smelter. Ore from the mines at Poland were processed at the Poland Mill. Ore from the mines at nearby Stoddard (above left, *c.* 1870s) were processed at the Stoddard Mill (below left, *c.* 1900). However the copper discoveries in nearby Jerome, northeast of Prescott over the Mingus Mountains, produced more money than all the mines in Yavapai County put together.

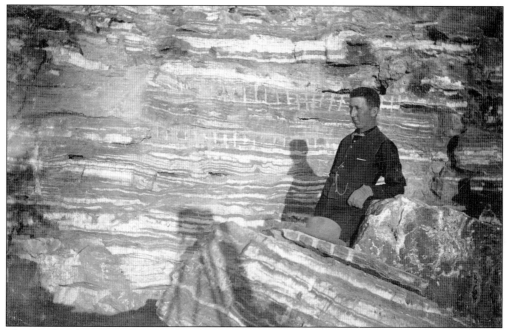

The Verde Silver in Jerome was located by Al Sieber, George Hill, and George B. Kell in 1876. Later in the year, John O'Dougherty, pictured here at the Onyx Mine around 1900, and his brother Edward filed on several claims there. In 1876, M. A. Ruffner filed on the Cassandry and the Eureka in the Jerome area and, in 1877, on the Wade Hampton, the Euclid, the Bonanza, and the Judge Wait.

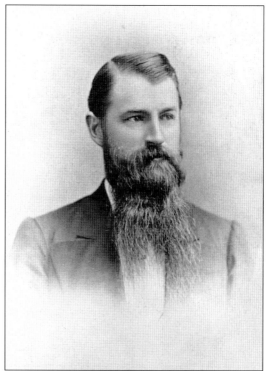

In 1882, Frederick A. Tritle, territorial governor from 1882 to 1885, leased several of those claims. In 1883, Tritle and New York financiers James A. McDonald and Eugene Jerome (pictured on the following page)—a cousin of Jenny Jerome, the mother of Winston Churchill—organized the United Verde Copper Company and bought most of those claims. Tritle is pictured here in 1880.

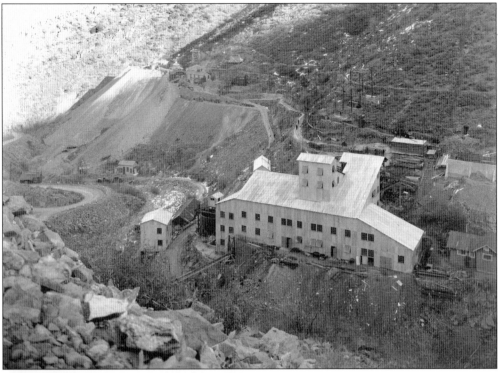

Early in 1889, production began at the United Verde (above, 1920s) with smelting at the 50-ton furnace built for that purpose. With this new smelter, the United Verde could process over three million pounds of copper per month. Unfortunately, in 1897, Jerome was devastated by fire. Nevertheless, stocked with tons of 3.5 percent ore in reserve, United Verde was able to survive. In 1900, J. J. Fisher and James A. Douglas purchased the Little Daisy Mine in nearby Clemenceau, which became the United Verde Extension (UVX). In 1916, a 300-foot-thick lode of 15 percent copper was discovered at UVX and, 100 feet deeper, a large deposit of 45 percent copper. By the time the United Verde and the UVX peaked in production, when copper prices rose dramatically during World War I, the population of Jerome was larger than Prescott. Eugene Jerome is pictured at left.

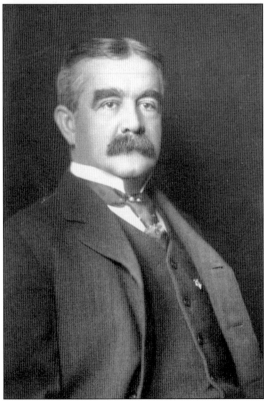

Five

RANCHING IN THE AREA

When not hunting Indians, King Woolsey was running cattle and putting up hay for the U.S. cavalry. The ruins of the Woolsey Ranch, east of Prescott, still remain. Closer to town, on Granite Creek, were the ranches of other members of the Walker party that included James Sheldon, Van C. Smith, John Forbes, and Rufus Farrington.

Many of the other early ranches were spread over Chino Valley and Williamson Valley north of Prescott. The Postle family in Chino Valley took over the original Fort Whipple at Del Rio in 1864. Phil McDonald started up the Long Meadows Ranch in Williamson Valley in 1872. Sometime after 1877, Johnny Koontz was raising cattle and horses and dry farming in the valley. In 1886, Bill Stewart started up the Cross Triangle Ranch. Henry Clark ran the first registered Hereford Cattle in the valley. His Las Vegas Ranch was located on the west side of "The Crossing" at Simmons Station, the way station established in 1880 for settlers coming to Yavapai County from the west. The Koontz and Stewart Ranches, as well as Simmons Station, were eventually bought by the Matli brothers, who ran a dairy farm there.

Southwest of Prescott, in the Peeples Valley, is where several other early ranches were located. Paulino Weaver homesteaded 160 acres at Walnut Grove in 1863, for instance, which was the ranch subsequently owned by the William Pierce family since 1881. T. B. Carter was running cattle in that area in 1864. Charles B. Genung started up a ranch there in 1871, running cattle and farming corn, beans, and potatoes.

Ranch life in the old days was difficult but could also be a lot of fun. Some of that fun had to do with annual round-ups—families getting together to brand their cattle—that resulted in the birth of the "rodeo." The first Prescott rodeo, the oldest rodeo in the world, was held on July 4, 1888. Juan Levias and "Arizona Charlie" Meadows split the bronc-bustin' prize. Juan Levias also won the Citizen's Prize for all-around cowboy.

Ranching is still going on in Yavapai County and is highly visible today. Cash from the annual calf sale at Hays Ranch in Peeples Valley, for instance, has been donated to the American National Cattlemen's Association since 1933. Though ranching is still around, however, massive numbers of people have taken up recent residence in the county and the vast range lands are quickly becoming converted to subdivisions.

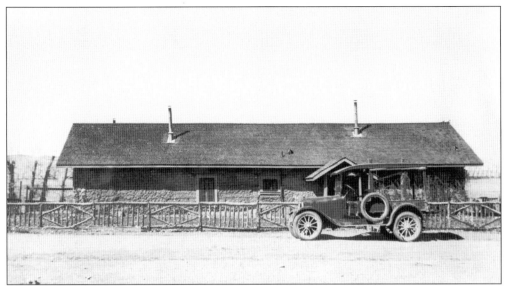

In 1864, the 500-acre Postle Ranch in Chino Valley (at the Del Rio site here in 1925) was producing some 200 tons of hay. They were also running cattle and horses. According to the *Arizona Miner*, as reported by Leavah Cooper Morgan in "Casa del Rio" (*Echoes of the Past*, Vol. I), hay at the time was selling for $80 per ton, barley and oats for $9 to $17 per hundredweight, wheat flour for $12 per hundredweight, eggs for $1 per dozen, and butter for $1 per pound.

In 1863, Rufus Farrington, pictured here around 1880, started a ranch near the site of the second Fort Whipple, growing five or six acres of corn without irrigation and an acre or so of cabbage, melons, and such, irrigated by means of a pump from Granite Creek. The next year, however, Farrington moved to Chino Valley and started a ranch there.

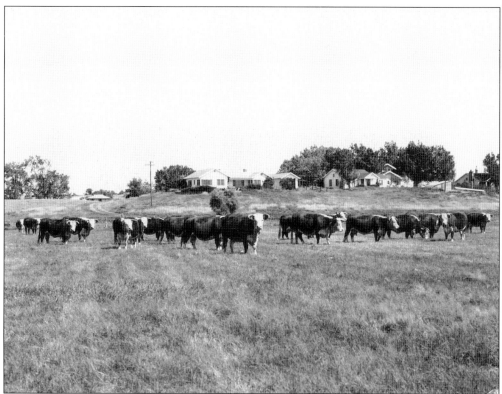

Among the ranches in Williamson Valley, north of Prescott, was the Long Meadow Ranch (above, *c.* the 1920s), started in 1872 by Phil McDonald. Sometime after 1877, Johnny Koontz was running the old Robert's Place in the upper Williamson Valley. Koontz broke teams of horses and sold them to Fort Whipple for $75 a team. In 1886, Bill Stewart (below right, as a child, *c.* 1920s) brought some horses and cattle with him from Williams and started up the Cross Triangle Ranch in the upper Williamson Valley. Charley Young also lived near the Cross Triangle Ranch. Young used to run wild horses with Cole McFern. Sometimes they would corral them at the Koontz place.

Henry Clark came to the lower Williamson Valley from Kirkland and bought the Las Vegas Ranch (above, 1960s), which was thought to have been started up P. J. McCormick in the early 1880s. Across Willow Creek from the Las Vegas Ranch was William J. Simmon's way station, also established sometime in the early 1880s. Here, for the convenience of travelers to and fro, was a post office (below, 1890s), a grocery store, four rooms to rent for the night, a dining room for serving dinner, and a barn with plenty of hay and grain for the horses or mules. Supplies for the station were brought out from Prescott about every two weeks. The mail was brought out every Friday.

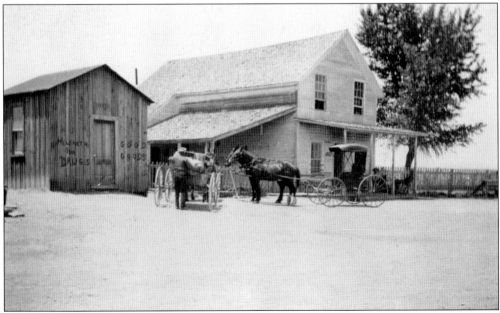

The site where the old Simmon's Station once stood was eventually bought by Matli brothers Angelo, Joe, John, and Frank for a dairy farm. Part of their dairy operation was making butter. As reported by Carl V. Koontz in "Willamson Valley," *Echoes of the Past*, Vol II.:

> They churned butter once a week; it was an all day job. They had a big cellar with a well in one corner and the cans of cream were kept in a well to keep cool until churning time. . . . The butter was . . . molded in wooden molds in both one-and two-pound sizes and was then wrapped in paper. Then it was placed in heavy wooden boxes ready to be loaded into the wagon for the trip to Prescott. Very early the next morning the butter was loaded and Malti would be on his way, generally around 3:00 or 4:00 in the morning.

The Matli brothers later ran Hereford cattle on their ranch, pictured here in the 1960s, which ultimately consisted of the Koontz and Stewart Ranches as well as land once owned by Zimmerman, Dillon and Baloat, and Ellis and Bagley.

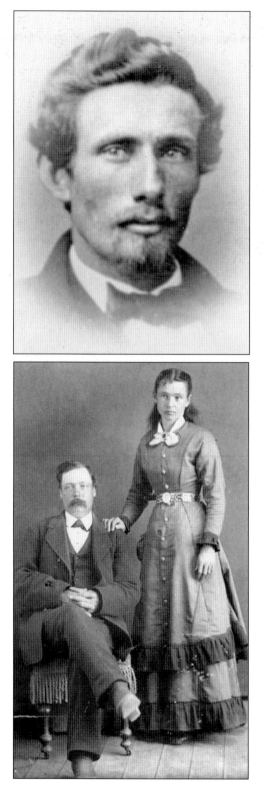

In 1871, another pioneer who came to Arizona, Charles B. Genung (above left, 1860s), started up a ranch in the Peeples Valley at Walnut Grove. Genung and his partner Elijah Smith ran cattle and farmed beans, corn, and potatoes that year. As noted by John Lee Fain in "Genung," *Echoes of the Past*, Vol II.:

> They sold the corn to the Bowers brothers on the Agua Fria Ranch at ten cents per pound . . . [and] sold about 150,000 pounds of potatoes at twelve and a half cents per pound . . . to every government post and town in the Territory. Including the hay they cut and sold, their crops brought them more than fifteen thousand dollars the first year. This did not include what they gave away to prospectors, who were never charged for whatever they could pack up and carry off.

T. B. Carter (below left, with his wife, c. 1877) also had a ranch in Walnut Grove.

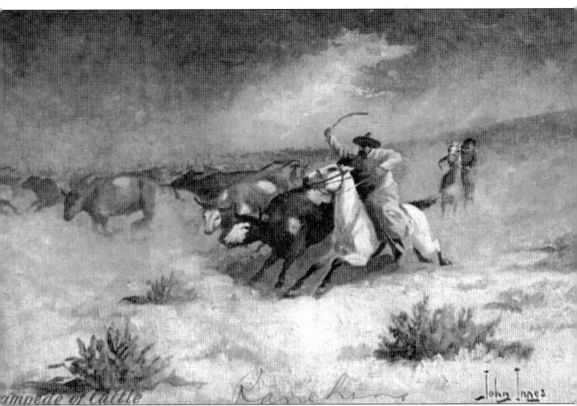

Stampede of Cattle — Rancheria — John Innes

Living on the frontier was difficult for ranchers such as T. B. Carter and his wife. For a woman, much of the work had to do with the family. As Leavah Cooper Morgan writes in "Casa del Rio," *Echoes of the Past*, Vol. I.:

> Producing much of the family's food in the home garden; milking cows and caring for the milk and butter; sewing nearly all the clothing worn by the family; tending a flock of chickens and other poultry for meat and eggs . . . in addition to rearing children, maintaining an orderly house, and cooking and serving great quantities of food for the meals eaten daily.

For a man, the difficulties created great character. As described by Johnny Lee Fain, Leavah Cooper Morgan, and Charles E. Mills in "Rodeo," *Echoes of the Past*, Vol. I.:

> His life had so taught him to endure that he faced sand storms, blizzards and 'bad times' all with the same degree of stamina and courage. He would ride anything on four legs. His rides were often long miles across deserts that quivered under a blistering sun . . . usually for long hours without food or drink.

As illustrated here, one such cowboy tries to stem a stampede out on the range, around 1900.

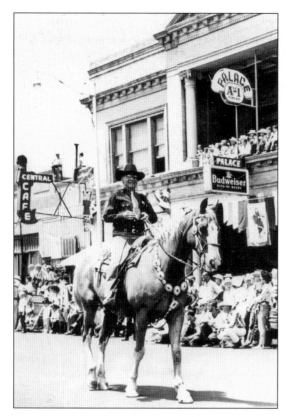

"Hard and lean as they were," however, as Prescott cowboy poet and pioneer descendent Gail Gardner remarks in *Orejana Bull*, "I believe I had more fun in the cowboy years than at any other time. Sometimes even now, I think I would like to get out and 'bust a loop.' " Gardner, at right, riding in the Frontier Days parade, ran stock in the Sierra Prietas with Van Dickson, the grandson of John Dickson, in the 1910s and 1920s.

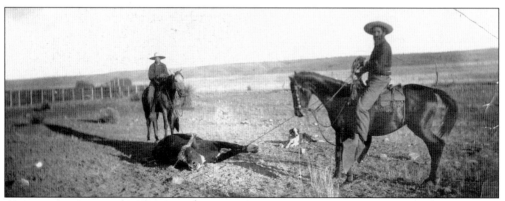

The first "rodeos" were held on local ranches during round-up and branding time when ranchers began staging "cowboy tournaments" in calf-roping, steer-roping, and bronc-busting for the entertainment of their neighbors, as pictured here c. 1900. Prescott's rodeos were originally held north of town at Granite Dells. After the county fairgrounds were built, the rodeos were then held there.

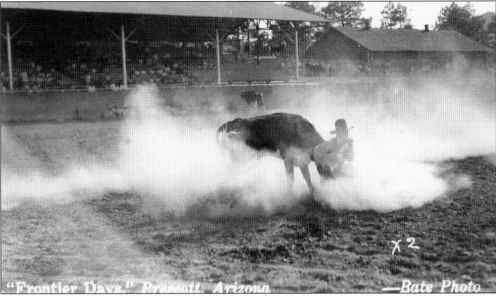

"Frontier Days," Prescott, Arizona —Bate Photo

Town fathers William Bashford, A. C. Burmister, and Morris Goldwater, among others, raised funds for prizes at the first Prescott Frontier Days Celebration and Rodeo, held on July 4, 1888. Juan Levias (right) and "Arizona Charlie" Meadows were the only two entries in the bronc-ridin' contest, so to be fair the riders traded horses for the competition. Both rode so well, however, the $50 prize was split between them. Levias also won the locally commissioned Citizen's Prize for steer-roping. Ladies also performed exhibitions in that first rodeo but did not compete for prizes. Since that first event, Prescott has produced several other champion cowboys, including three-time World Champion All-Around Cowboy Everett Bowman (above, 1930s).

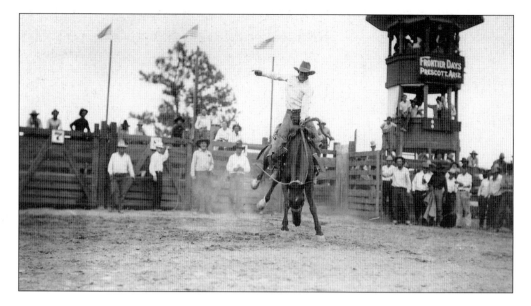

World champion bronc rider Perry Henderson (above) and team ropers Brad Smith and George Richards (below) also came out of Prescott. Among other local cowboys popular in the rodeo were Ritchie Lewis, Lawton Champie, Joe and Ab Rudy, Oscar Roberts, Bert and Buck Jackson, Dave Berry, Grant, Charley, and Jim Carter, Walter Cline, Joe Bassett, Frank Condron, and Joe and Van Dickson. "This Fourth of July celebration was a time of great excitement for us boys," recalls long-term resident Dixon Fagerberg in *Meeting the Four O'Clock Train and Other Stories*, "We got jobs selling pop, peanuts or hotdogs in the grandstand and, in the bargain, got to see all the action. It was a great show every year."

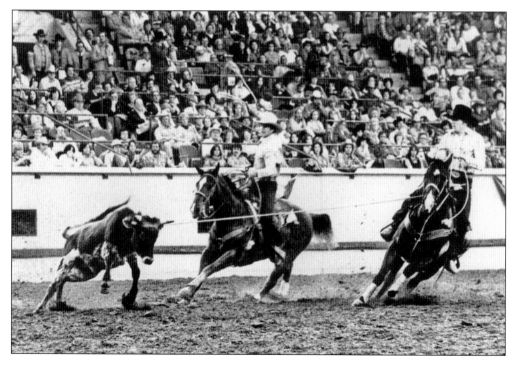

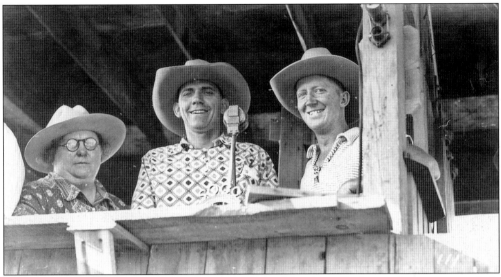

Those locals credited with making the Prescott Frontier Days Rodeo such a success include arena directors C. W. "Doc" Pardee and Lester Ruffner; the well-known chairman of the Yavapai County Board of Supervisors, Clarence C. Jackson; official timers Homer R. Wood and Grace Sparks (left), a long-term fan of the rodeo, pictured here with "Happy" Mintz (center) and Myerl Shipp (right).

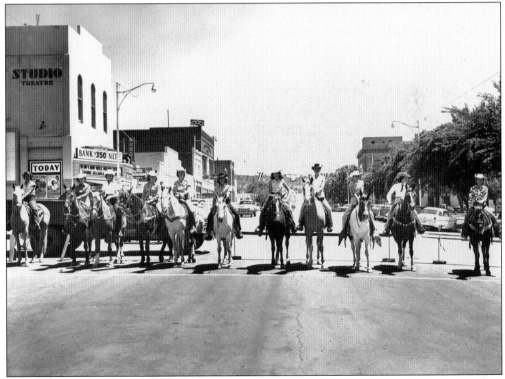

Pictured here around 1955 is the Frontier Days parade preceding the rodeo, which has featured such notaries as Will Rogers and Barry Goldwater. Richard Milhous Nixon, who in 1928–1929 spent his summers in Prescott as a boy, once worked in an amusement booth at the parade.

In 1933, stemming from the efforts of Kirkland's Clarence Jackson (above left) and Prescott's Edwin S. Turville (below left), a former agricultural agent in the county, the "Yavapai Calf Plan" was born, which donated cash benefits from the annual calf sale at Hays Ranch in Peeples Valley (opposite page, above) to the American National Cattlemen's Association each year. To this end, an annual calf sale and barbeque continues to be held in the fall at the Hay's Ranch to the present day.

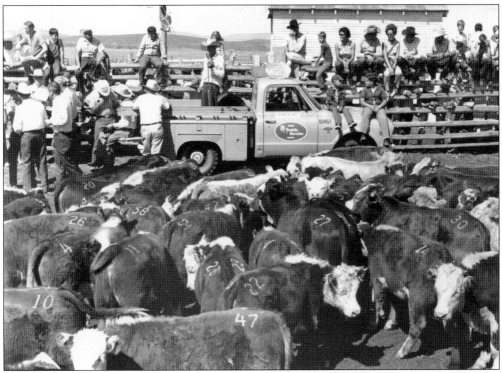

First held at the Bar Muleshoe Ranch in Peeples Valley, the annual calf sale at Hays Ranch, pictured here in the 1960s, has donated thousands of dollars to the National Cattlemen's Association.

Since the founding of the Yavapai Cattle Growers Association in 1932 by Cort Carter "to advertise Yavapai County cattle and work for the general interest of the cattle industry," as quoted by Danny Freeman in "Yavapai Calf Plan," *Echoes of the Past*, Vol. II, cattlemen in the county have been actively involved with the American National Cattlemen's Association. Cort Carter (right, c. the 1950s) is the great grandson of T. P. Carter, a pioneer rancher in Peeples Valley.

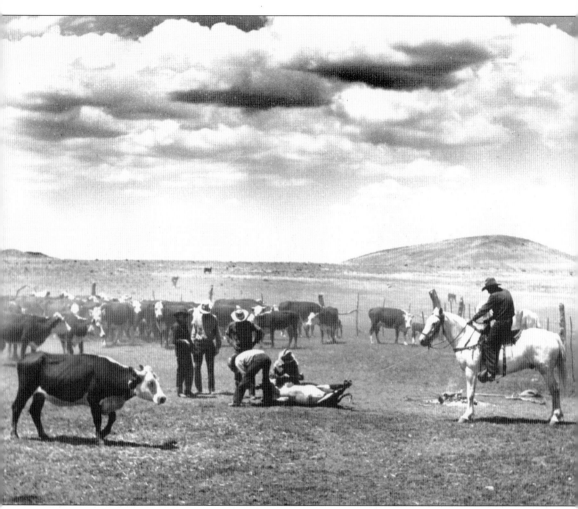

As once feared by cattlemen when the railroads came into the Prescott area, the big ranches, such as the Fain Ranch in Chino Valley pictured here, are gradually disappearing. Beginning in 1966, the huge Fain family holdings, between Highway 69 and 89A east of Prescott, including the area originally known as "Lonesome Valley" and later "Jackass Flats," was developed into the community now known as Prescott Valley. Such development continues as Young's Farm in Prescott Valley, 160-plus acres operating as a turkey farm since 1947, was recently sold for the creation of yet another subdivision. The population of the tri-city area of Prescott Valley, Chino Valley, and the city of Prescott itself now numbers some 80,000 people.

Six

EARLY ENTREPRENEURS

By the end of the 19th century, downtown Prescott was becoming rapidly developed. On Gurley Street, facing the Plaza to the north, were E. A. Kastner's cigar store, C. P. Head's hardware, the Bashford-Burmister Mercantile Company, and Hubbard's Drug Store. On the northeast and southeast corners of Gurley and Cortez Streets were the temporary headquarters for the Prescott National Bank and the first Bank of Arizona. On the southeast and southwest corners of Goodwin and Montezuma Streets were the Plaza Stables and the Scopel Hotel. In 1895, the offices of *The Prescott Morning Courier* had been moved to the Scopel block.

Montezuma Street, or "Whiskey Row," facing the Plaza to the west, was host to Cobweb Hall, the Cabinet Saloon, and Bob Brow's famous Palace Saloon. In the middle of the block was Pat Kearney's saloon, with Prescott's first telegraph office in the back. Dominating the Plaza itself was the Yavapai County Courthouse, built in 1878.

Elsewhere in town were a number of other significant enterprises. Among them were Maier's Corner Saloon, on the corner of Gurley and Granite Streets, and the Union Saloon, on the corner of Granite and Goodwin Streets, with the "Red Light" district strung out between them. North on Granite Street was Chinatown. Across the bridge on West Gurley Street was the O.K. Grocery and Corral. North on Montezuma Street was the Brinkmeyer Hotel. On the corner of Montezuma and Willis Streets was the Montezuma Hotel, reportedly the first hotel in Prescott. South on Montezuma Street was the Sherman House. North on Cortez Street was the Prescott Hotel, the Head Hotel, and J. I. Gardner's general store. Up East Gurley Street, where the Hassayampa Hotel now stands, was the Congress Hotel.

Just across Gurley Street was the "Capitol block" with the front half occupied by the Territorial Capitol Building, which was constructed in 1876 to house the legislature. It became Prescott Elementary School in 1892. The back half was converted into the exclusive "Nob Hill" section of Prescott in 1893.

The most important new enterprise in Prescott, however, was the railroad. Thomas Bullock built the Prescott & Arizona Central Railway in 1886. After that, in 1893, the Santa Fe, Prescott & Phoenix Railway began service, thanks to the efforts of Frank Murphy, Levi Bashford, C. P. Head and others, hooking up in Ash Fork with the Atlantic & Pacific Railroad.

At the turn of the 20th century, the town of Prescott was thriving and business was booming. Prescott was putting itself on the map. Then came the fire of July 14, 1900.

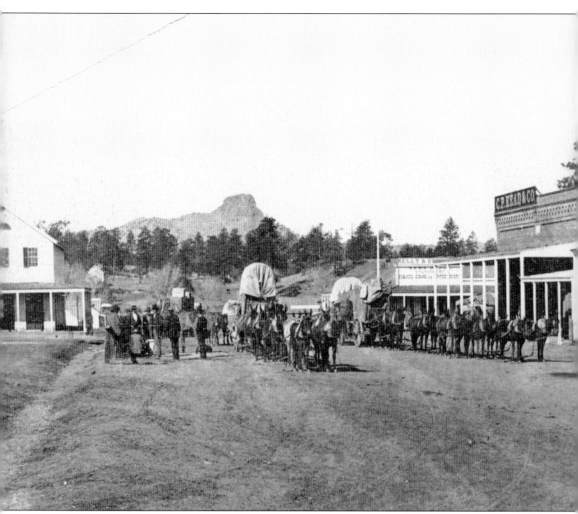

This early photograph of downtown Prescott, looking west toward Thumb Butte, depicts a Carr's Freight team on Gurley Street sometime between 1875 and 1880. As documented by Melissa Ruffner in *Prescott: A Pictorial History*:

The building to the left, on the southwest corner of Montezuma and Gurley streets, was the Diana Saloon, owned by an Englishman, 'Uncle Joe' Crane. This site was later occupied by the Hotel Burke, today the Hotel St. Michael. Businesses to the right are Kelly and Stephens Company, C. P. Head and company, and Prescott's first drugstore, the Pioneer. The November 7, 1879, *Arizona Miner* carried the following ad: 'Doctor Kendall, at the Pioneer Drug Store, received during the week three thousand pounds of goods in his line and is now prepared to kill or cure on short notice.' The Pioneer Drug Store burned to the ground on March 5, 1885, and was not rebuilt.

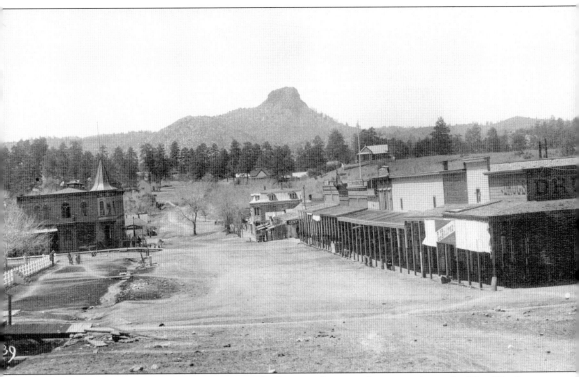

This later photograph of downtown Prescott, looking in the same direction, shows the Hotel Burke on the southwest corner of Montezuma and Gurley Streets. Further west on Gurley Street, in the background, Meyer's Corner Saloon can be seen. On the northwest corner of Gurley and Cortez Streets, in the foreground at the extreme right, is Hubbard's Drug. The photographs on both of these pages feature the prominent Thumbe Butte in the background. This was the landmark that Gen. James H. Carleton told the governor's party to look for while trying to locate a site for an Arizona territorial capital. That site, of course, eventually became the town of Prescott.

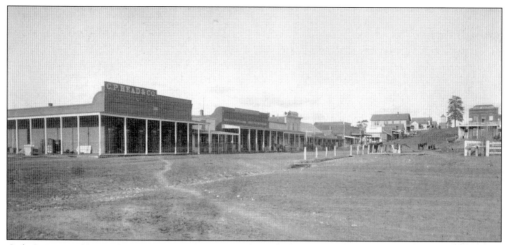

Col. C. P. Head started out in the hardware business in 1866 with an outlet on the corner of Gurley and Montezuma Streets (above). By 1878, he also owned a lumber yard and the Head Hotel on North Cortez Street in Prescott. Levi Bashford established the Bashford Mercantile Company on Gurley Street in 1868. Later Bashford brought in his nephew William Bashford (below) and partnered with Robert H. Burmister, changing the name of the business to the Bashford-Burmister Mercantile Company, also known as the "B&B" or "B-B," in 1874. The Burmister and Bashford families were related by marriage. Frank Murphy, the mining, railroad, banking, and real estate magnate, was also a partner.

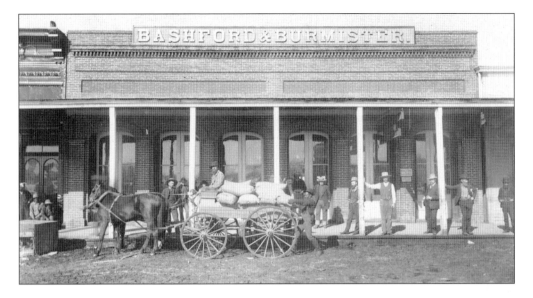

These two photographs feature the first Bashford-Burmister stores on Gurley Street as they looked in the 1880s (above) and after expansion in the 1890s (below). The later building boasted a water-powered elevator. According to Melissa Ruffner in *Prescott: A Pictorial History*, "The Bashford-Burmister Company was one of the largest mercantile stores in northern Arizona, carrying everything from mining supplies to domestic and imported cigars, from Blue Will dishes to fresh fruits and vegetables." In the early 1940s, after some 70 years of operation, the B&B was replaced by the J. C. Penney Company. To the left of the B&B in the image below is the Winsor Hotel.

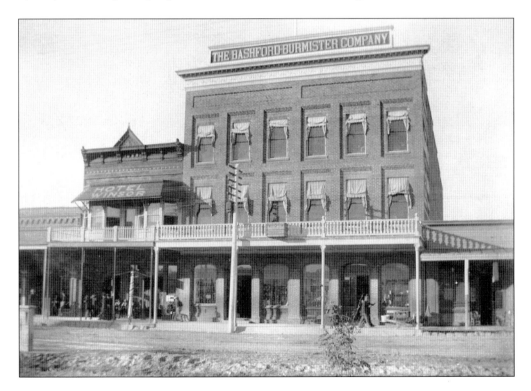

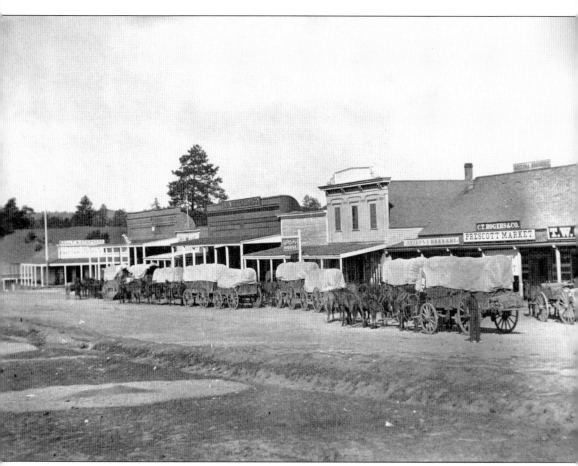

Legislative Hall, pictured here around the 1880s in the middle of Gurley Street as the only building without a false front, was originally built to house the territorial legislature. In 1879, however, after the legislature moved to Curtis Hall on Granite Street, the building assumed commercial use. In the 1880s, the Arizona Brewery and W. H. Smith's meat market occupied the building. In this photograph, from left to right, are the Dudley House, the Arizona Brewery, the Prescott Meat Market, and the T. W. Otis Building. Theodore W. Otis, the Prescott postmaster from 1875 until 1884, ran a jewelry business here. Later he built the T. W. Otis Building on the northwest corner of Cortez and Union Streets.

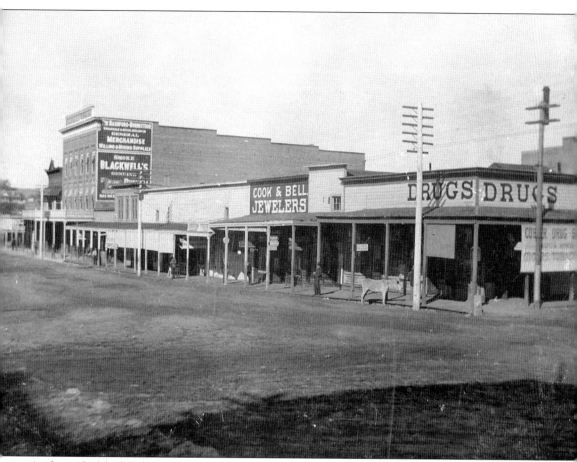

At the end of the block was George W. Cook's jewelry store and Hubbard's Drug. Melissa Ruffner, in *Prescott: A Pictorial History*, wrote, "From 1888 to 1899, Hubbard's Drug Store was owned by William W. Ross (who opened another drugstore at 115 South Cortez in May 1900). Harry Brisley, who also owned the Mountain City Drug Store on Montezuma Street, purchased the Corner Drug Store from Ross on January 19, 1899." Later on, Brisley moved his drugstore, pictured here on Gurley Street *c.* the 1890s, into the Knights of Pythias Building, the former location of the McCandless drugstore and soda fountain. In 1925, Brisley sold his business to W. W. Bontag. Much of Prescott's history has been preserved by being featured on Brisley's famous picture postcards. The original Hubbard's Building, on the northwest corner of Gurley and Cortez Streets, eventually became the Eagle Drugstore and part of the Bashford block.

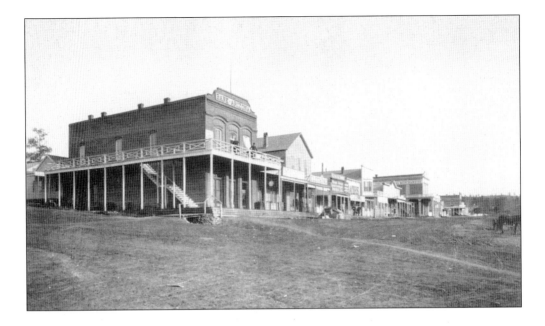

On the southeast corner of Gurley and Cortez Streets stood the first bank in the territory, the National Bank of Arizona, which was chartered by Martin W. Kales and Solomon Lewis in 1877. In 1887, William E. Hazeltine, along with Hugo Richards and Edmund W. Wells, purchased the bank and ran it until his brother took over in 1893. In 1900, construction began on a new building to replace this wooden one (above, 1880s). Meanwhile the bank ran its business in the Electric Building next door (below, up the hill). The bank's safe, however, would not fit through the doors of the Electric Building and had to be left outdoors on the sidewalk. The new building, which still stands today, was finished in 1901. Ultimately the Bank of Arizona was taken over by Wells Fargo.

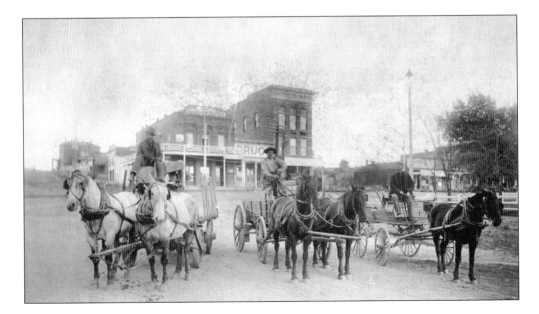

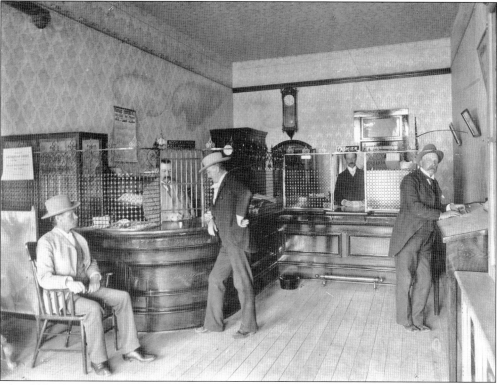

The old bank, pictured here in the 1890s, was noted in *A Photographic Tour of 1916 Prescott, Arizona,* by Nancy Burgess and Richard Williams, for such "practical features" as the teller's cage with "an abacus to aid in dealing with the Chinese customers" and "a large scale for weighing gold." Oddly, though, Hazeltine "often kept the sacks of gold in the wastebasket, covered with paper." In this image, from left to right, are E. W. Wells, Mr. Martini, Buckey O'Neill, Moses B. Hazeltine, and Hugo Richards.

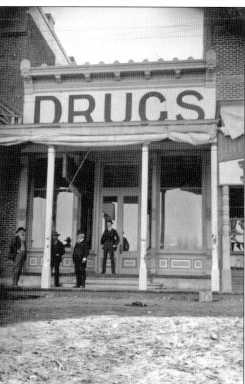

In the rear of his drugstore and soda fountain, pictured here around the 1880s, Dr. James Newton McCandless maintained his office. One of the doctor's prescriptions, a cathartic, was called the "4950," named for the most powerful rifle at the time.

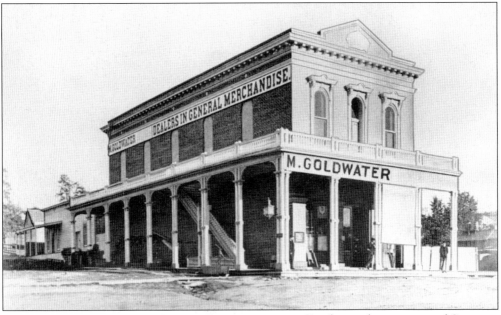

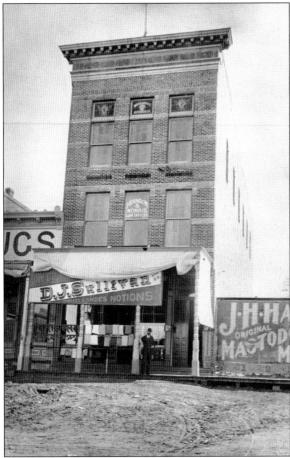

On the southeast corner of Cortez and Union Streets was the second Goldwater and Brothers Store, completed in 1879 and pictured here around the 1880s, which had a second floor that became the second Masonic Temple. Goldwater's remained in business until the 1950s. Their high-Victorian, Italian-style building was demolished in 1978.

In this 1890s image at 105 South Cortez Street is the Knights of Pythias Building, which was also known as the Tilton Building or the Hawkins-Richards Building. Constructed in 1893 by John Herndon, John Hawkins and Hugo Richards, this is one of the oldest buildings in Prescott. The Knights of Pythius Building was also the tallest structure in town at 46 feet, and it housed law offices on the second floor and the meeting room for the lodge on the third floor.

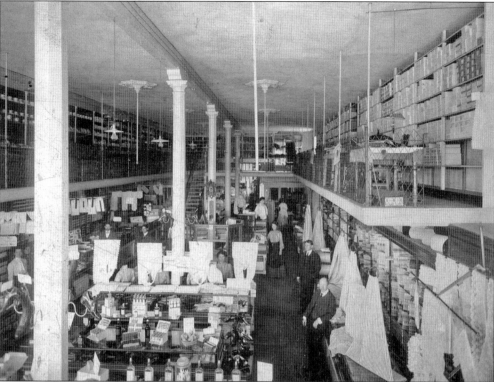

Previously Goldwater's "had been general merchandisers, carrying mining supplies, farming implements, and hardware, in addition to soft goods and foodstuffs," but in their new store, managed by Mike Goldwater's son Morris, "They catered to the ladies," according to Melissa Ruffner in *Prescott: A Pictorial History*. This photograph of the store is from around the 1890s.

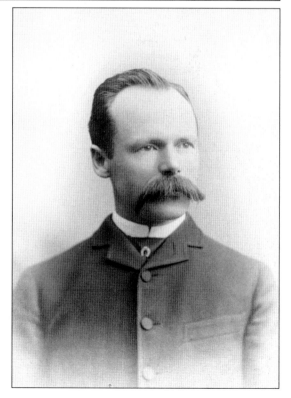

Morris Goldwater, pictured here in 1888, "was instrumental in the promotion of the Prescott and Arizona Central Railroad, was a founder of the Prescott National Bank, and helped organize the Prescott Rifles, later the nucleus of the Arizona National Guard . . . was a member of tree state legislatures, instituted the first paving of city streets, and served as mayor for 22 years," states Melissa Ruffner in *Prescott: A Pictorial History*. Morris was also the uncle of Sen. Barry Goldwater.

The Goldwaters started their merchandising business in Los Angles. After the Civil War, Michael Goldwater, pictured here, and his brother Joseph began a freighting business on the Colorado River, shipping grain for the government out of Ehrenberg. In 1863, Mike was situated on the mouth of the Colorado River at La Paz. In the early 1870s, he opened a store in Yuma, and in 1876, he moved with his son Morris to Prescott.

The first Goldwater's store, opened in 1876, was located in a building on the southeast corner of Cortez and Goodwin Streets and was the first lot ever sold in the original town site. After Goldwater's moved into their second store, this building was converted into Howey's Hall, the city's first opera house. Howey's Hall was demolished in 1959 to make way for Prescott's new city hall.

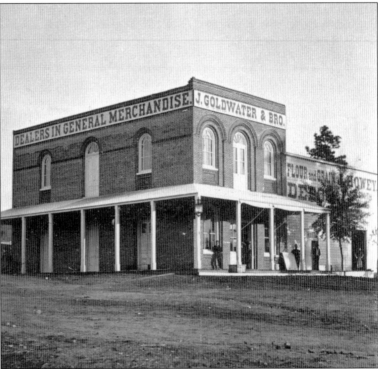

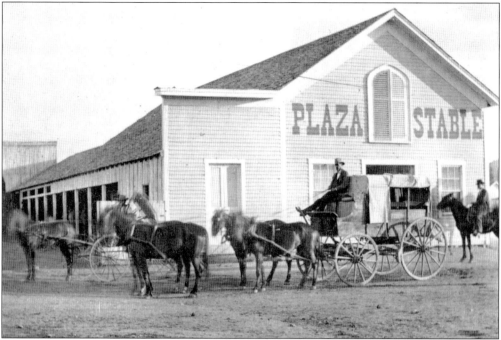

On the southeast corner of Goodwin and Montezuma Streets was the Plaza Stables and Shoeing Shop (above), owned by George C. Ruffner (below), who was the county sheriff in 1894. As described in later years by Dixon Fagerberg in *Meeting the Four O'Clock Train*, "There was nothing quite like a livery stable with all the horses, stalls, haylofts, grain cribs, buggies, carts and wagons, all of it pervaded by a uniquely pleasant odor." After the arrival of the automobile in Prescott, Ruffner became the first dealer for the J. I. Case car.

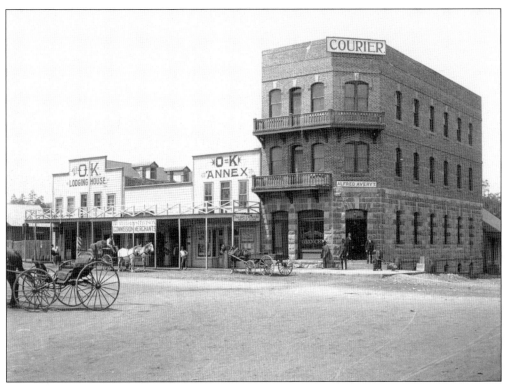

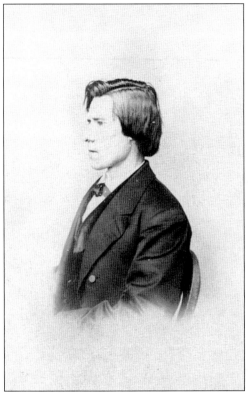

Before the offices of *The Prescott Morning Courier* were moved to the Scopel Hotel, pictured here in 1895, they were located on the second floor of the first county courthouse on North Cortez Street. E. A. Rogers had taken over the *Courier* after John Marion's death in 1891. Marion founded *The Prescott Morning Courier* in 1882, the paper that later became *The Prescott Evening Courier* and eventually *The Daily Courier*, as it's known today.

Richard C. McCormick, bringing a printing press with him from the East, established the *Arizona Miner* at Fort Whipple in 1864. McCormick sold the *Miner* in 1867 to Benjamin H. Weaver and John Huguenot Marion, the man posing in this image from around the 1870s. Marion sold the *Miner* in 1875 and started up two other publications, the *Enterprise*, published from 1878 until 1879, and the *Arizonian*, published from 1879 until 1880, before starting up *The Prescott Morning Courier*.

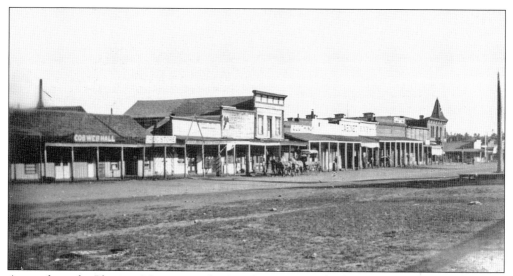

Across from the Plaza on Montezuma Street, of course, was the famous "Whiskey Row" (above, c. 1894), a whole block of establishments dedicated to drinking, gambling, and bawdy entertainment. The first bar in Prescott, the Quartz Rock Saloon, was moved by Isaac Goldberg to Whiskey Row from Granite Street sometime back in the middle 1860s. Toward the turn of the century, the most famous establishments on Whiskey Row were Cobweb Hall, owned by former Colorado River steamboat captain P. M. Fisher; the Sam'l Hill Hardware (below), which was moved to Montezuma Street by Sam Hill in 1879; the Cabinet Saloon, owned by Barney Smith and D. C. Thorn; and the Palace Saloon, owned by Bob Brow.

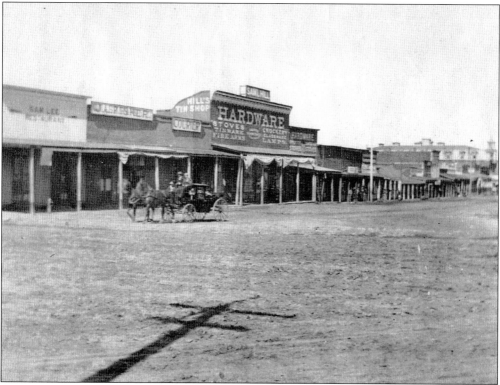

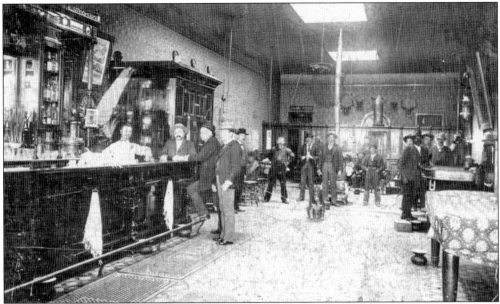

The best-known bar on Whiskey Row was Bob Brow's Palace Saloon, pictured here around 1890. This cowboy and miner hangout first opened in 1877 and featured a 24-foot-long carved mahogany bar, shipped there by an ox team in 1880. Still in operation today, the Palace is reputed to be the oldest saloon in Arizona.

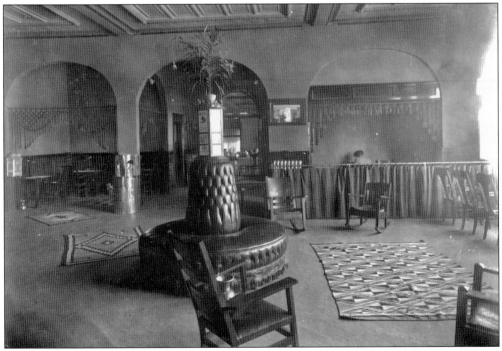

At the end of Montezuma Street, on the southwest corner of Montezuma and Gurley Streets, was the Burke Hotel. Sometime after 1901, Dennis A. Burke sold the hotel to Michael Hickey, who renamed it the Hotel St. Michael. From 1907 to 1935, the hotel was owned and operated by John Duke. This lobby photograph was taken sometime in the 1890s.

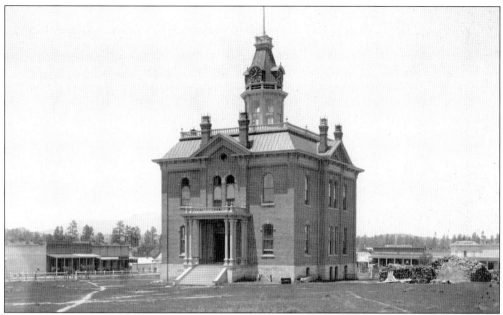

The new pink-brick Yavapai County Courthouse, surrounded by a white picket fence to keep out the livestock, stood in the center of the Plaza from 1878 until it was demolished in 1916. The original courthouse, a two-story, clapboard structure built in 1867 by Levi Bashford, was located on North Cortez Street.

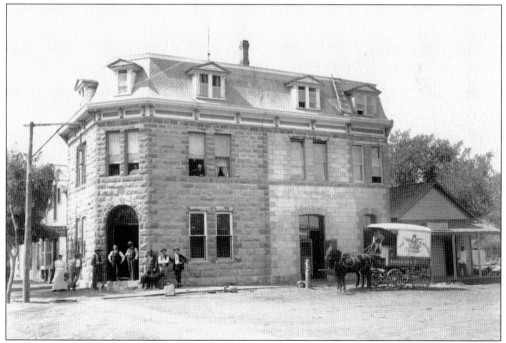

On the northwest corner of Gurley and Granite Streets was Martin Maier's Corner Saloon, formerly known as the Exchange Saloon and Lodging House and established in 1891. Later this building became the New Golden Eagle Hotel, owned by R. T. Tindall. Its final name was Rex Arms—demolished as such in the 1950s.

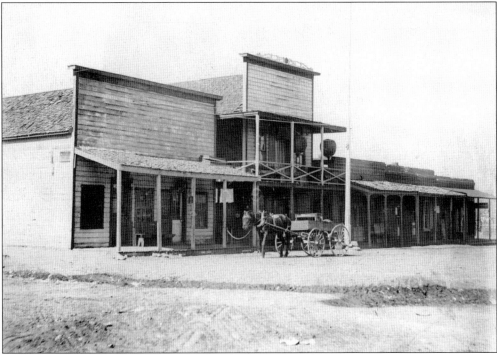

North along Granite Street, between Granite Creek and Montezuma Streets, was Chinatown, home to some 70 or 80 business people including the owners of several restaurants, grocery stores, and laundries. At center of this *c.* 1885 photograph is the Joss House, the Chinese temple and men's social club.

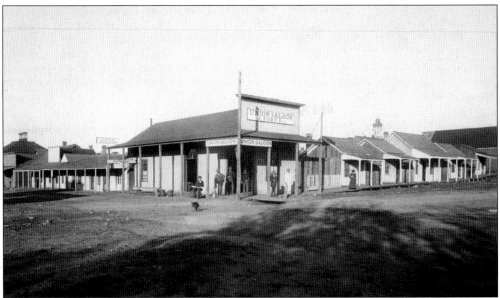

South on Granite Street, strung out between the Corner Saloon and the Union Saloon on the corner of Granite and Goodwin Streets, were a row of "female boarding houses" or "cribs," pictured here around the 1880s. "Ladies of the evening," or "soiled doves," also hung out on Whiskey Row; other women were not allowed.

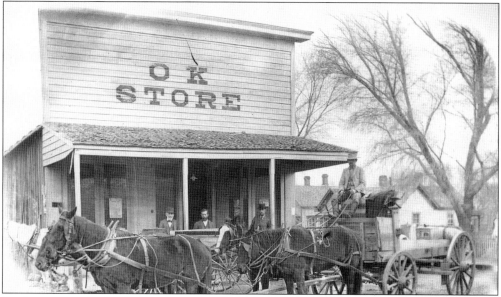

Further west on Gurley Street, across the bridge on the northeast and northwest corners of Gurley and McCormick Streets, was a complex that included the O.K. Cash Grocery, pictured here in the 1890s, and the O.K. Corral, established by John Dougherty in 1878. Customers at the grocery store could stable their teams and wagons at the O.K. Corral.

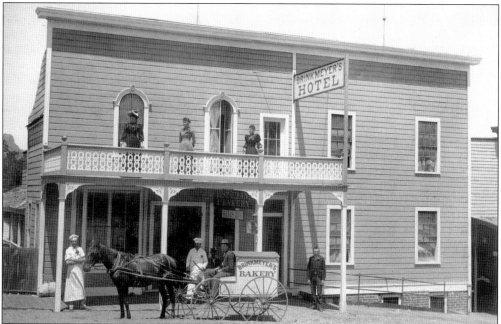

Pictured here in 1896, north on Montezuma Street close to Gurley Street, is the Brinkmeyer Hotel with a restaurant specializing in German food and beer, which later added a bakery. Henry Brinkmeyer got his first job as a baker at the Prescott Hotel, owned by the Shuermann's, who came with Brinkmeyer from Germany to Prescott in 1884. In 1890, Brinkmeyer bought the Summer House Hotel next door and started his own business. Brinkmeyer continued to run the hotel until 1930 and the bakery until his death in 1941.

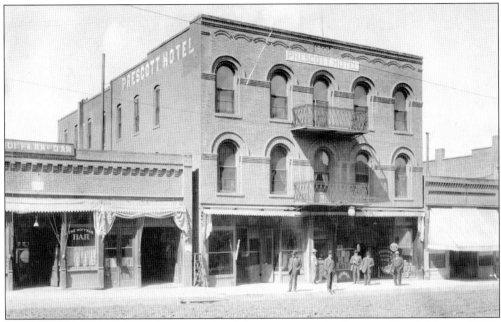

North on Cortez Street, on the west side of the street, was the Prescott Hotel (above, 1900). Across the street and further north on Cortez Street was the J. I. Gardner Building (below), built in 1890, which is now Murphy's Restaurant. According to Melissa Ruffner in *Prescott: A Pictorial History*, "Gardner's carried everything: coffee (Arbuckle's included a stick of peppermint candy in their cans; flour; sugar; canned goods; dress material; horseshoes; hay; grain; salt; boots; shirts [and Levis]; coats; hats; pots and pans; dishes; toys; underwear; shovels; pain; kerosene; potatoes; crackers; dried fruit; tea; vinegar; spices; candles; wallpaper; sheep dip; fresh fruits and vegetables; household furnishings and much more. . . . Gardner even filled mail orders each afternoon, taking them to the train which dropped off the requested items."

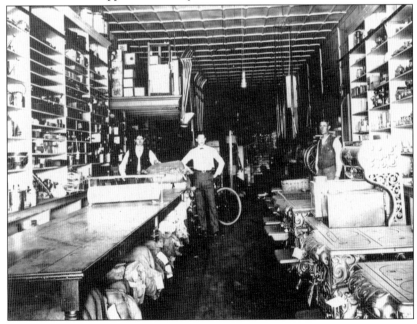

Up East Gurley Street, on the north side, was the Congress Hotel. Built in 1870, it was first known as the Williams House. It was purchased in 1895 and renamed the Congress by Mrs. Anna McGowan, who owned stock in the nearby Congress Mine. The Congress Hotel was destroyed by fire in 1924.

Just across the street, on the south side of Gurley, was the former Capitol block. The front half was occupied by the Territorial Capitol Building, pictured here c. the 1880s, which was constructed in 1876 to house the territorial legislature on the top floor and Arizona's first graded school, the Prescott Free Academy, on the bottom floor.

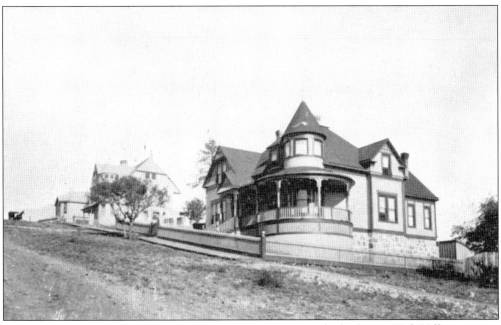

The homes on Nob Hill are characterized by three architectural styles: territorial frame (the Lawler/Heatherington double-house), Victorian melange (the Goldwater residence), and Queen Anne (the Peter and Marks residences, pictured here c. 1895). The double house at the top of the hill—a 12-room house divided by a common wall—was built for John Lawler's brother M. A. Lawler and Robert Hetherington.

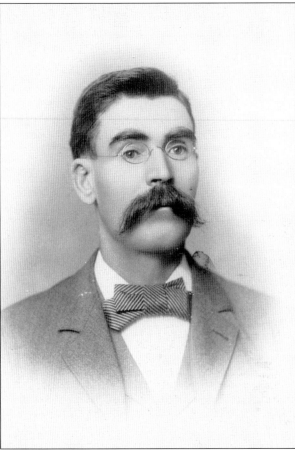

In 1893, the back half of the former Capitol block was auctioned off and converted into the exclusive Nob Hill section of Prescott. This is an 1890 image of John Lawler, who built a house at the top and sold the other lots to Henry Goldwater, C. A. Peter, and Jake Marks, all of them successful entrepreneurs. Henry was one of the Goldwater brothers, C. A. was a cashier at the Bank of Arizona, and Jake was a rancher, miner, and liquor dealer.

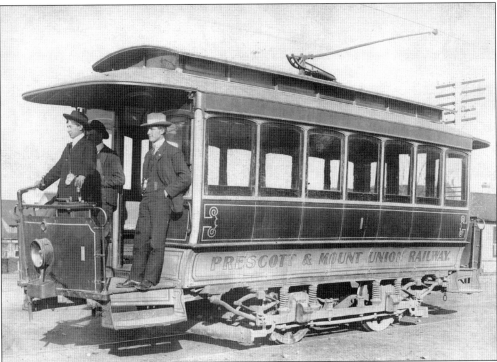

Frank Wright (right) developed a streetcar business in Prescott, the Mt. Union Electric Street Car Company, which ran from 1905 to 1912. The streetcars went from Park Avenue on West Gurley Street across town to Fort Whipple. Later a line was added running north on Cortez Street from Gurley Street to the Santa Fe Depot. Two more enterprises of critical importance in Prescott were the electric and phone companies. In 1894, Wright established the Prescott Electric Telephone Company as well as a direct-current generating business at the Electric Building, on 107 East Gurley Street, which still stands today. In 1898, Wright and his partner Job M. W. Moore built an alternating-current plant at the north end of McCormick Street.

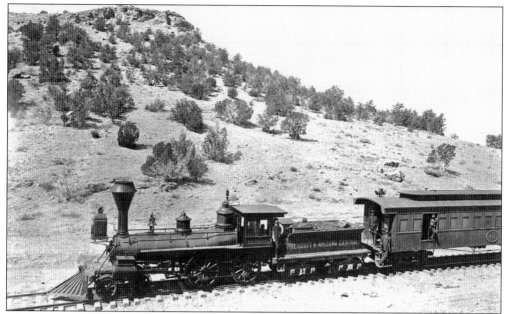

The first railroad enterprise, The Central Arizona Railroad Company, was actually organized back in 1884. Known as Bullock's Railroad, the Prescott & Arizona Central Railway (above, 1887) was completed by Thomas Seaman Bullock in 1886, running from Prescott to Prescott Junction (the present-day site of Seligman, Arizona), where it hooked up with the Atlantic & Pacific Railroad. This system was plagued with problems, however, such as having no wye or siding, which made the train run in reverse the entire way back to Prescott Junction. This, among other issues, resulted in the line being sold for taxes in 1893. Soon after, the Santa Fe, Prescott & Phoenix Railway (below, at "Point of Rocks" in 1896) began service, running from Prescott to Ash Fork, via Chino and Williamson valleys, where it hooked up with the Atlantic & Pacific Railroad. The SFP&P was continued on to Phoenix in 1895.

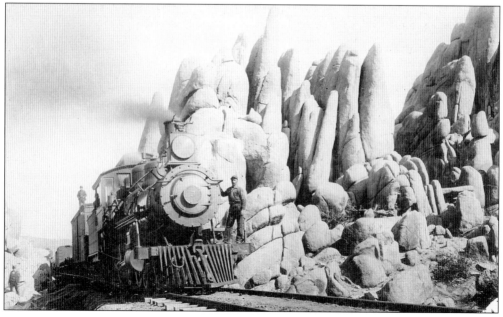

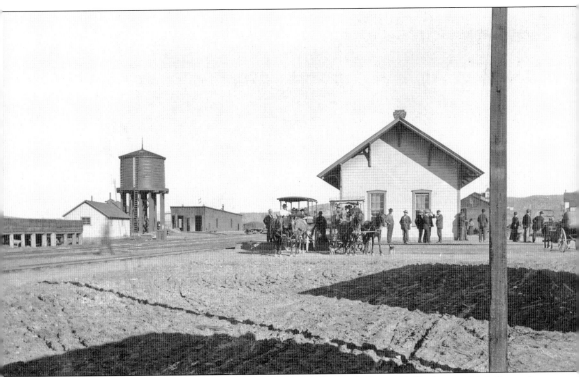

Eventually, the SFP&P became part of the Atchison, Topeka & Santa Fe Railway, which figured prominently in the growth of commerce in Prescott. Ore from mines in the area and cattle, sheep, hides, and wool from the ranches were exported via the train. Equipment and coke for the mines, food, dry goods, hardware, lumber, fuel, and other supplies were imported. The first railroad station, pictured here in 1894 and constructed in 1893 at the extreme north end of downtown Prescott on Cortez Street, was destroyed (along with the roundhouse) by an explosion in 1898. The Santa Fe depot (pictured in 1910 on the next page), built after the explosion, still occupies its original site on Sheldon Street and is remodeled and known as the Depot Marketplace.

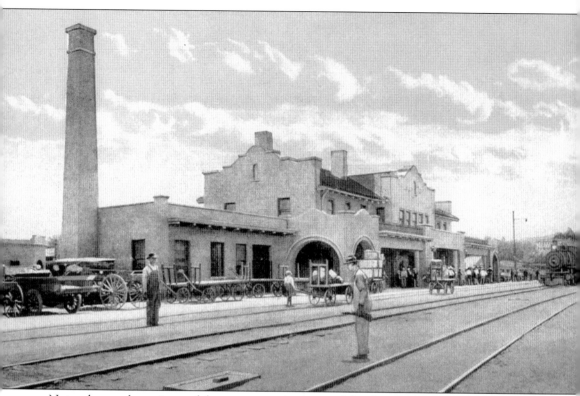

Not only was the train good for commerce, it was good for the social life of Prescott as well. The arrival of the southbound train of the Atchison, Topeka & Santa Fe, known as "the four o'clock train," for instance, was quite an event, according to Dixon Fagerberg in *Meeting the Four O'Clock Train*:

> There was something of a commotion at the depot at that hour every day. If you wanted a little afternoon diversion, it was fun to go down to see the train roll in and the passengers getting on and off. . . . Near Fort Whipple the engineer always let out a long blast of the whistle and everyone at the station would say, "Here it comes!"

Passenger service on the AT&SF continued until 1962, when a bypass route eliminated the need for a line between Prescott and Skull Valley. All service ended in the early 1980s.

Seven

THE GREAT FIRE

Saturday, July 14, 1900, 10:30 p.m.: It was a hot and humid night in Prescott, the beginning of the monsoon season. And there were water restrictions. The city reservoir was nearly empty, and to make matters worse, the pumping plant at the city's only well was about to be overhauled and the engine was disconnected from the pump. The four wells on each corner of the Plaza that had been Prescott's original water supply had long been in disuse and had been covered over.

As hot and uncomfortable as it was, however, the streets were still full. It was Saturday night. Cowboys and miners were thronging to the joints down Whiskey Row. No doubt everyone was quite shocked when the big bell in the court house tower started clanging and the siren on the power plant started blasting, signaling the great fire that was already engulfing the Scopel Hotel.

Because there was a wind from the south, the fire quickly took over, spreading north from the Scopel Hotel, jumping Goodwin Street, and starting up Whiskey Row. Within just a short while, the blaze roared up Montezuma Street until it reached the Burke Hotel on the corner. The Burke went up as well, the flames jumping Montezuma Street and heading east up Gurley Street. With no water available, the only hope of stopping the fire was to destroy the buildings in the path of the flames so that there would be no fuel left to burn. Since the blaze was already almost to the Bashford-Burmister store, the Dudes Hose Company began clearing the buildings on Cortez Street.

Finally, at 3:30 a.m., the great fire was subdued, but most of the downtown area was devastated. Financial losses figured to be $1.5 million. The pioneer spirit of the people of Prescott, however, would persevere. Everybody pulled together.

Early the next morning, tents and temporary tin shacks were erected on the Plaza and were doing business as usual. The Bashford-Burmister donated what foodstuffs they had left to the firefighters. Henry Brinkmeyer, whose bakery was destroyed, continued baking in the ovens at Fort Whipple and had his goods for sale. The Palace Bar partnered with the Cabinet Saloon to continue their business. Gaming tables were set up, drinks were served, and a piano that had been rescued from the fire was playing "There'll be a Hot Time in the Old Town Tonight."

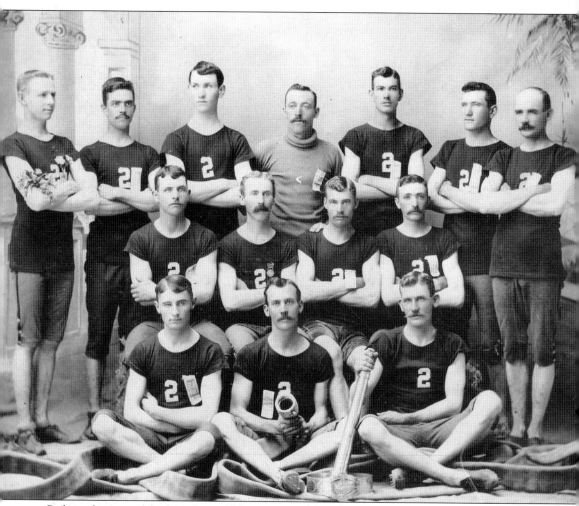

Perhaps the story of the fire is best told by Dewey Born, whose father Charles, pictured here at left in the first row, c. 1890, was there fighting the fire. As Dewey reports in *Stories of Early Prescott*:

Late in the afternoon, a miner by the name of [Ed] Harold came in from his diggings and checked into the Miners' Home in the 200 block of South Montezuma. He lit a candle, which was in a miner's candle stick on the wall, and about 10:00 P.M. took his pail and went for water. . . . While he was away a strong breeze came up from the south and blew the curtain into the candle flame. . . . Bert Lee and Martin Testora [*sic*] with the Hook and Ladder Company made the run up Granite Street to the hydrant. Martin connected the hose while Bert ran up the alley to the Miners' Home and into the burning room with his hose. He saw the candle stick in the wall but no candle. The room was ablaze but could be easily put out except for the fact that no water came out of the hose. Bert backed out and ran back to the hydrant which was wide open but there was no water.

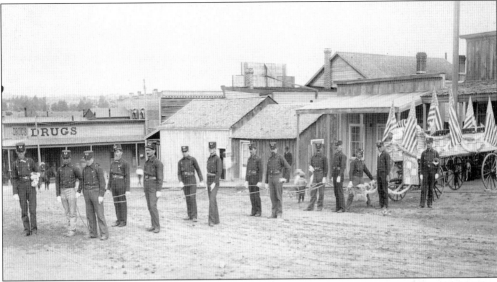

Though there is some confusion about exactly where the fire started, as some think it began in the Scopel Hotel, Dewey Born's account in *Stories of Early Prescott* has Martin Testori (right, *c.* the 1890s) with the Hook and Ladder Company (above, *c.* 1891) there on the scene, at the burning room of the miners' home next door. "The noise of the fire was frightening," continues Dewey. "The roar of the flames was punctuated by explosions. Large quantities of powder, ammunition, gasoline, kerosene and other volatile materials were stored in the buildings and exploded as they burned. The explosions as buildings were dynamited ahead of the fire added to the roar."

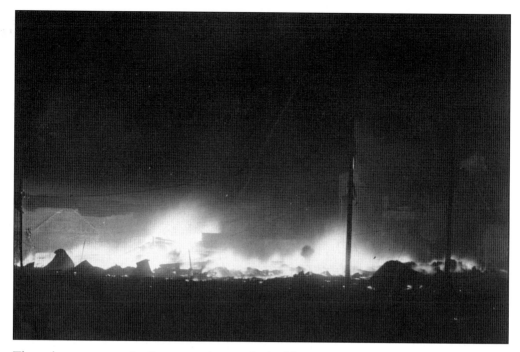

The only way to stop the fire was to destroy the buildings in its path. Since Charles Born had extensive experience with dynamite working with his father, Henry, in the mines, he set out to clear what was left of North Montezuma Street. As stated in D. E. Born's *Stories of Early Prescott*, "Realizing how the owners would feel about having their buildings destroyed ahead of the fire Charles went down to the bicycle shop he owned, next the Brinkmeyer Hotel, and blew it up first. He then worked south on Montezuma Street, blowing up each building as he came to it, until he got to the Wilson Building on the corner, but it was already on fire."

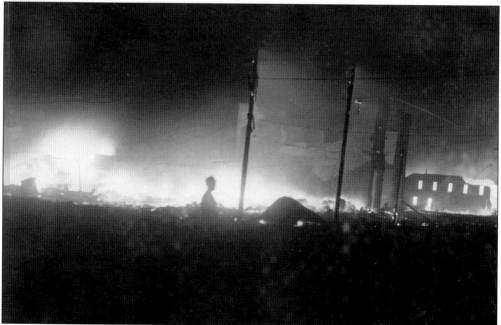

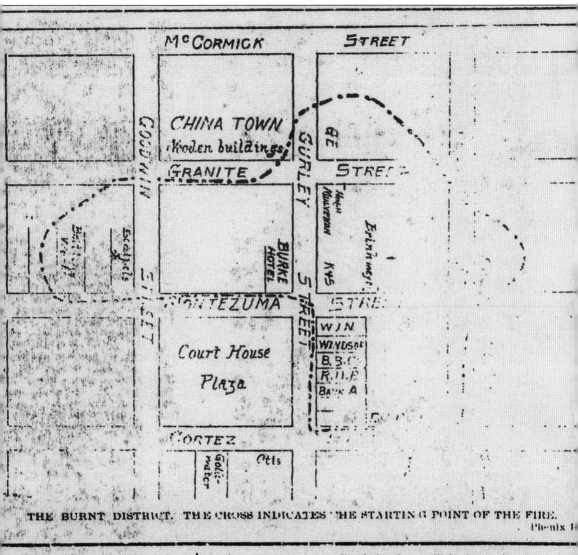

THE BURNT DISTRICT. THE CROSS INDICATES THE STARTING POINT OF THE FIRE.

Phœnix

P. & E. railroad brought quite a number from points along that road. of the exacting and discriminating duties which have heretofore been will be in session three days to be of unusual importance...

A hastily produced, typewritten newspaper called *The Howler*, substituting for the burned-out *Prescott Morning Courier*, summarized the damages to the downtown area as outlined on this map. As Etta J. Oliver writes in "Prescott's Big Fire," The Yavapai Cow Belles, *Echoes of the Past*, Vol. I.:

> The fire gradually destroyed the entire block which contained Whiskey Row on Montezuma street and all the houses on Granite street, leaped across from the Hotel Burke (St. Michael) to Wilson's corner on Gurley Street. Two blocks were destroyed between Gurley and Willis and Granite and Cortez streets. The fire crossed the street from Mulvenon's Saloon and ignited the Golden Eagle Hotel, extending north the entire length of the block, but did not reach across Granite Creek. Chinatown, on the west side of Granite street was saved by the hard work of its occupants. Three blocks and a half of the business portion of the city were destroyed in about five hours. The fire was stopped at Willis Street.

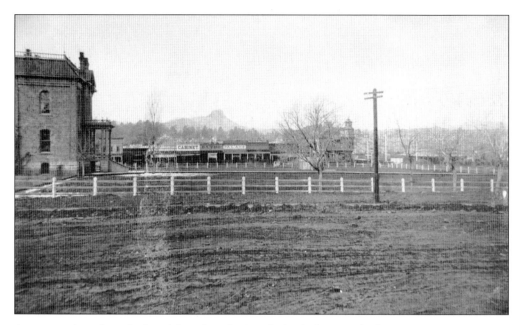

As pictured in these before (above) and after (below) shots, Whiskey Row on Montezuma Street was completely demolished. Nevertheless, as also seen in these photographs, burned-out businesses were already reorganizing, putting up tents and temporary shelters. As Etta J. Oliver documents in "Prescott's Big Fire," The Yavapai Cow Belles, *Echoes of the Past*, Vol. I.: "Even though two-thirds 'of our pretty little town and all but three or four of the business houses were wiped out by Saturday night's fire,' reports *The Howler*, 'Our people are cheerful withal, and, instead of whines and groans, there is the merry sound of hammer and saw as a temporary town rises rapidly on the plaza.'"

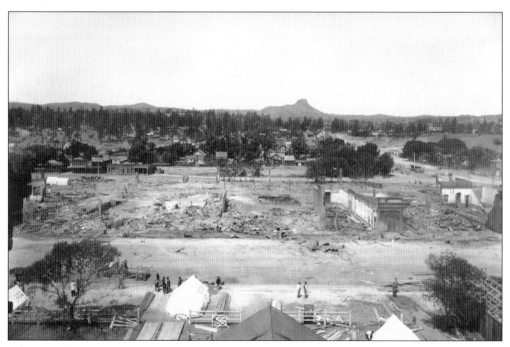

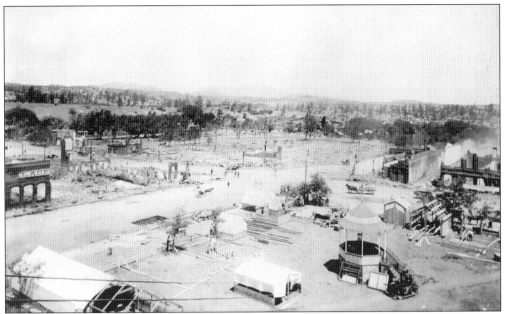

Notice the Burke Hotel (above, to the right of the burned-out Palace), advertised later as "the only absolutely fire proof hotel in Prescott," left in rubble, as the flames jumped to Gurley Street and continued north up Montezuma Street toward Willis Street (above, extreme right). After the flames leaped Montezuma Street and headed east up Gurley Street toward the Bashford-Burmister store (below, left), Charles Born detoured up the alley and joined the rest of the Dudes Hose Company to begin clearing the buildings on North Cortez Street. On North Cortez and Willis Streets, the fire was stopped.

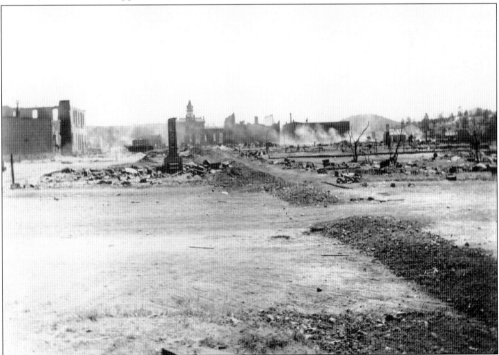

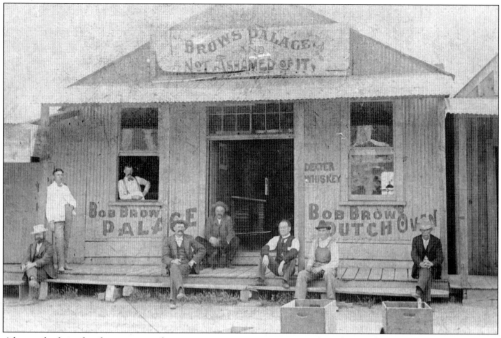

Almost before the fire was out, businesses were setting up on the Plaza. The Palace Bar partnered up with the Cabinet Saloon to continue business in a new corrugated-tin shack, complete with the 24-foot-long mahogany bar that had been carried over to the Plaza during the fire. "Brows Palace And Not Ashamed Of It" read the sign (above) painted on the front of the hastily built digs. Whiskey was available for 10¢ and beer for 5¢. Sam Hill's Hardware was back in business in a makeshift building on the Plaza. C. B. Linn's jewelry store (below) was back in operation on the Plaza as well. The bandstand in front of the courthouse on the Plaza was converted into a barbershop, and someone set up a tent with tubs for baths.

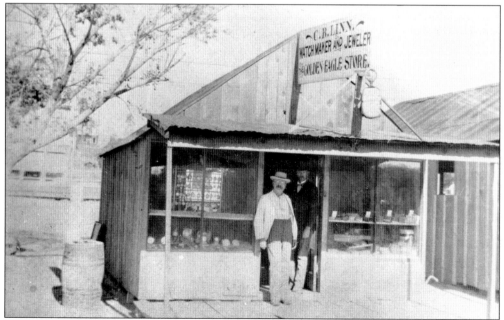

Sheriff Johnny Munds (above right) took charge of the money for various businesses. The Bank of Arizona, whose temporary quarters on West Gurley Street were destroyed in the fire, saved some of their furniture. When their safes cooled down to the touch (below right), the combination doors were opened and banking was conducted on the Plaza. Though the exact amount of the damages was difficult to determine, it was soon discovered that the financial losses caused by the great fire were extensive.

Nevertheless, as the *Prescott Morning Courier* reported, after resuming publication five days later, relocating its offices to a nearby barn (above), "That the town will be rebuilt more substantially than ever is a well-settled fact, as nearly all property owners have so expressed themselves." In the Plaza across from Gurley Street and the ruins of the Bashford-Burmister (below), locals are already set up and doing business.

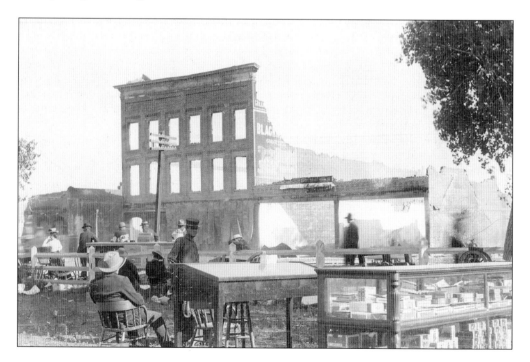

Eight

STATEHOOD AND STABILITY

Among the few buildings surrounding the Plaza that remained standing after the great fire of July 14, 1900, were the Prescott National Bank, under construction on the northeast corner of Gurley and Cortez Streets; the Bank of Arizona, also under construction on the southeast corner of Gurley and Cortez Streets; and the Knights of Pythias Building next door.

Soon after the fire, rebuilding began with a vengeance. Moreover the new buildings of brick and stone were not only far more substantial than the old frame buildings, but were characterized by architectural styles that brought an antique dignity to the downtown area.

Financed by Frank Murphy himself (having been turned down by Moses Hazeltine at the Bank of Arizona), the new Prescott National Bank was a monument to neo-classical revival. The new Bank of Arizona was designed in the second renaissance revival style.

Other businesses on the Plaza also sprang back to life: E. A. Kastner's and Bashford-Burmister's on Gurley Street; the Sam'l Hill Hardware on Montezuma Street; the N. Levy & Company store on Montezuma Street, rebuilt in a Romanesque revival style; the Palace Saloon, rebuilt in a neo-classical revival style; and the Hotel St. Michael (formerly the Burke), rebuilt on the corner of Montezuma and Gurley Streets.

The rebuilding that took place after the great fire—in addition to the diversity that mining and ranching provided—created a solid economic base for Prescott, making it possible to survive the mining slump of 1905, the assault on gambling in saloons in 1907, Prohibition in 1914, and even World War I and the Great Depression. Prescott's status as the county seat further enhanced its importance as a regional commercial hub. Then, too, statehood in 1912 became a stimulus for commerce.

After the beginning of World War I in 1914, however, Prescott's economy stabilized somewhat and the population leveled off. Not until the 1930s did a slow upturn in growth begin to take place. The continued development of business and professional opportunities contributed to some of that new growth, but most important was the coming of the automobile. And once automobiles and services for them became readily available, motor courts and more hotels were soon to follow. As traffic increased to Prescott, the town began to emerge as a major resort attraction, a prime destination for tourists and health enthusiasts. The rich history, the local economy, the salubrious climate, and picturesque landscape made Prescott one of the most desirable communities in the country.

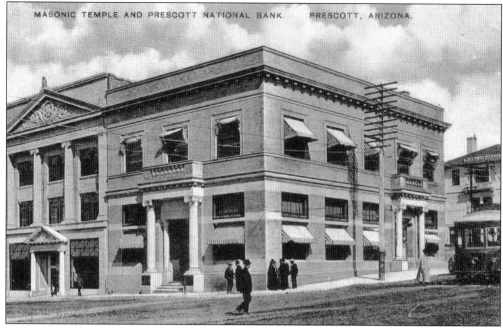

The Prescott National Bank was originally organized by William C. Bashford and Morris Goldwater in 1885. When the bank was charted in 1893, with Frank Murphy as president and Morris Goldwater as vice president, the bank building was located on South Montezuma Street. The new Prescott National Bank Building on the corner of Gurley and Cortez Streets (above), completed in 1902, boasted two giant granite columns at each of its entrances. At 40 feet high, the building was slightly higher than the Bank of Arizona across the street (below, at right, 1903), and extended 75 feet along Gurley Street and 50 feet along Cortez Street. From 1923 to 1957, this building was the home of the Valley National Bank.

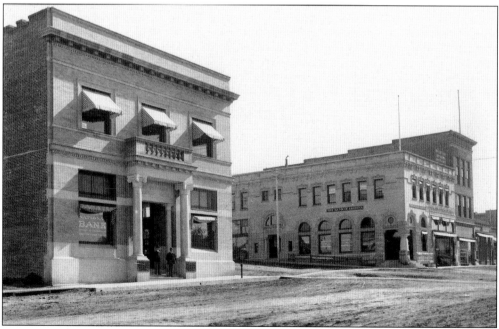

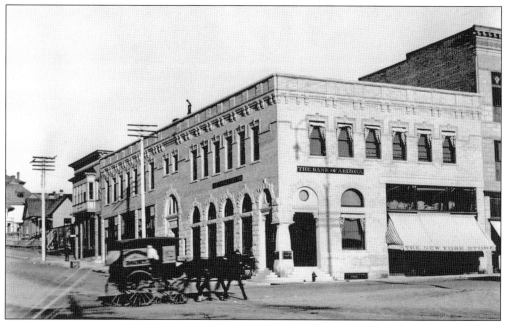

The new Bank of Arizona Building, completed in 1901, was designed in the second renaissance revival style. It extended 118 feet up the hill along Gurley Street and 52 feet along Cortez Street. Its entrance on the corner of Gurley and Cortez Streets was dominated by a single, solid, granite column.

E. A. Kastner rebuilt his store, pictured here in 1908, on the corner of Gurley and Montezuma Streets and expanded to become the sole agent in town for such exotic items as Hunt's High Quality Fruits, Batavia canned goods, Crosse and Blackwell's products, Hills Brothers Highest Grade Coffee, and Gunther's Famous Candy. Later Kastner's became a Piggly Wiggly.

Sam'l Hill rebuilt his hardware store, as pictured here, on Montezuma Street. Although Hill died shortly after, his widow Amy continued running the store, which eventually became the largest supplier of hardware, mining, ranching, and household goods in the area. Later the Samuel Hill Company became the first automobile dealer in Prescott, in 1903 and 1904, as agents for Olds and Thomas cars and in 1915 as the agents for Ford.

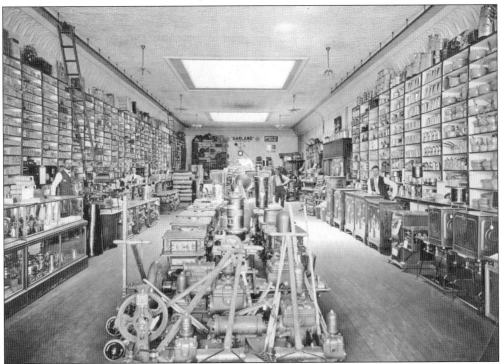

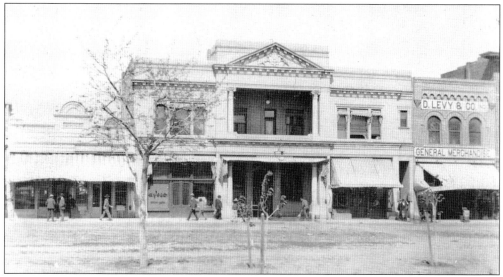

Bob Brow partnered with Barney Smith and Ben M. Belcher to rebuild the Palace Saloon (center, 1905) in its original spot next to D. Levy and Company (at right). Not only was the Palace rebuilt as a saloon, with a gambling hall in the basement, but it also became a hotel with a barbershop, shoe-shine stand, and a restaurant.

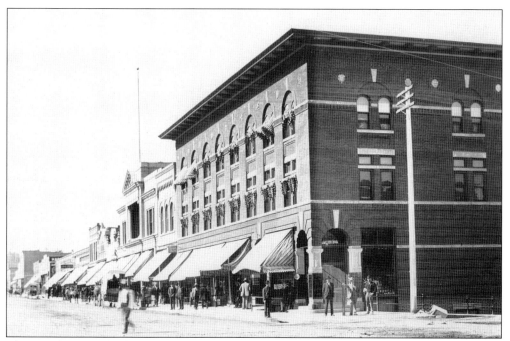

The Hotel St. Michael, pictured in here 1902, was rebuilt on the corner of Montezuma and Gurley Streets, becoming one of the finest hotels in Prescott. It accommodated such famous guests as Theodore Roosevelt, John L. Sullivan, Will Rogers, Tom Mix, Zane Grey, and Sen. Barry Goldwater, among others, with a restaurant boasting the finest continental cuisine in the country.

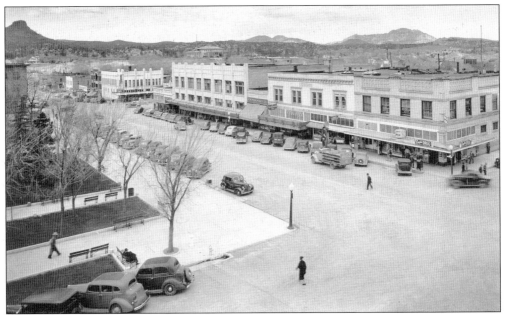

Almost all of the buildings reconstructed around the Plaza, pictured here looking west down Gurley Street, contribute to a strong sense of history in that they are not only architecturally significant—one, two, or three stories with simple brick facades, decorated with brick coursing and pediments—but they give a consistent and unique look that is preserved in downtown Prescott even today.

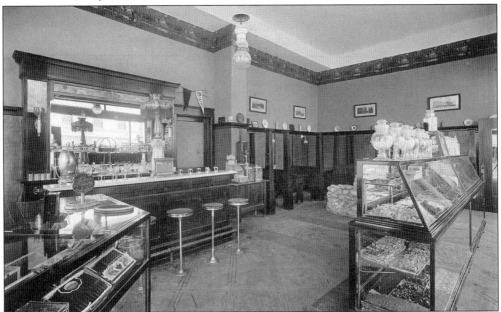

Among new businesses springing up after the fire was The Owl Drug and Candy Company on the northwest corner of Gurley and Montezuma Streets. Owned and operated by Ed Shumate and his mother, as described by Dixon Fagerberg in *Meeting the Four O'Clock Train*, Owl Drug "was the place to go for a treat . . . a chocolate ice cream soda or a strawberry sundae . . . after the concert, after the movie, after the game, after the play, even after a party."

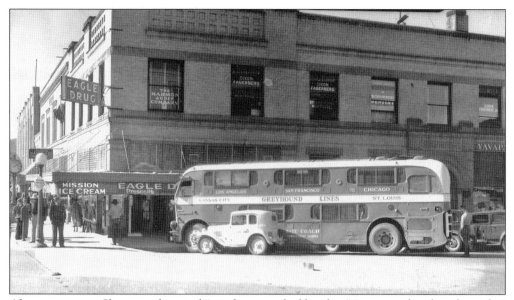

Also a restaurant, Shumate advertised "nice home cooked lunches," "oyster cock-tails and tamales" and "Bulk and Eagle Brand oysters in season." In 1932, Eagle Drug, pictured here around 1935, replaced Owl Drug with a lunch counter "where you could buy the best five-cent cup of coffee in town," Melissa Ruffner, in *Prescott: A Pictorial History*, documents. The Eagle continued serving customers, including such famous visitors as Doris Day and Robert Mitchum, until it closed in 1974. Other restaurants in town included Scholey & Scholey's pool hall on North Cortez Street, which offered lunches, and Pete Ching's and Hong Yon Yee's in Chinatown.

The Arizona Power Company, formerly the Prescott Gas and Electric Company, had taken over Frank Wright's enterprise in 1910 and moved to North Cortez Street, pictured here in 1910. Mountain States Telephone took over the telephone business in 1912.

Most of the attorneys in town had offices in the Prescott National Bank Building or the Bank of Arizona Building. Prominent attorneys included LeRoy Anderson (above, 1910), the former member of the territorial House of Representatives and author of the Separation Bill, which admitted Arizona and New Mexico to the United States as separate states. Another established attorney there was Henry Fountain Amherst, one of the first U.S. senators from the state of Arizona. J. M. W. Moore & Son (below, 1910), originally operating their real estate and insurance business out of their offices in the Prescott National Bank Building, moved to the Head block on North Cortez Street.

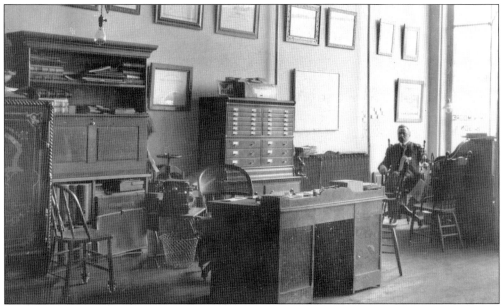

The third Yavapai County Courthouse (above), the one that still stands in the middle of the Plaza today, was built in 1916—with offices located in the basement of the courthouse. Yavapai County was the largest single county ever created in the United States. As one of the four original counties in Arizona, Yavapai County at one time occupied almost half the entire territory, 65,000 square miles in all. Even after Maricopa, Apache, Navajo, Gila, Coconino, Pinal, Graham, Greenlee, and Mohave were subtracted from it, Yavapai was still the 14th largest county in the U.S., about the size of the state of New Jersey. The new U.S. post office and federal courthouse (below) was built across from the county courthouse on the corner of Cortez and Goodwin Streets in 1932.

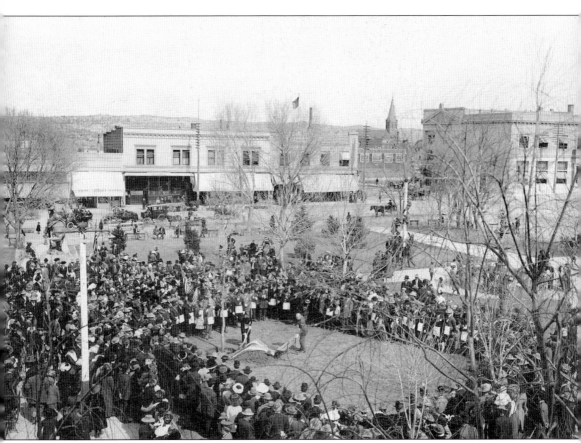

On February 14, 1912, Arizona became the last state in the continental United States to be admitted into the union. William Howard Taft was president at the time, George P. Hunt was governor, and members of the territorial council were now members of the state senate. On Admission Day in Prescott, businesses decked themselves out in bunting and flags, literary exercises were performed on the Plaza, patriotic songs were played by the Prescott band and sung by the school children, and a statehood tree was planted on the Plaza, pictured here. At 12:00 p.m., the bell on the courthouse tolled 48 times and all the bells and whistles in town were sounded, joined by the ringing of 10 blacksmith anvils on Whiskey Row.

In 1913, the Arizona Good Roads Association, under the direction of Grace Sparkes, pictured here at the Prescott Chamber of Commerce, published a tour guide with detailed maps and a list of business associated with the automobile, the first such guide in Arizona. The automobile provided access to Prescott from all distances and directions.

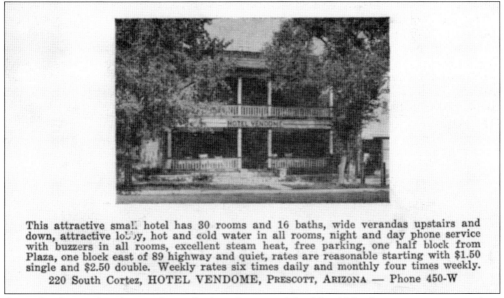

This attractive small hotel has 30 rooms and 16 baths, wide verandas upstairs and down, attractive lobby, hot and cold water in all rooms, night and day phone service with buzzers in all rooms, excellent steam heat, free parking, one half block from Plaza, one block east of 89 highway and quiet, rates are reasonable starting with $1.50 single and $2.50 double. Weekly rates six times daily and monthly four times weekly.
220 South Cortez, HOTEL VENDOME, Prescott, Arizona — Phone 450-W

Accordingly new hotels were being built in Prescott. The Hotel Vendome was constructed on South Cortez Street in 1917 as a resident inn for health-conscious visitors. The Vendome was also the headquarters for film star Tom Mix, who made a number of movies in Prescott, many of them set at Granite Dells.

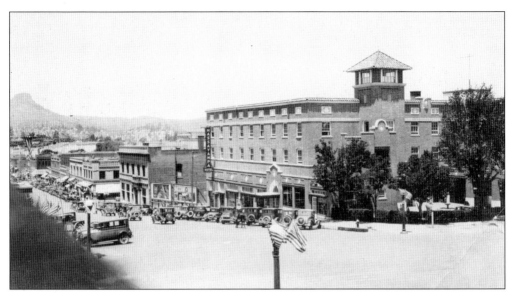

The Hassayampa Hotel (above, c. 1927) was built on East Gurley Street in 1927, replacing the old Congress Hotel. The Hassayampa, a community-owned hotel, was expressly built to attract and accommodate the increasing number of tourists who were flocking to the Prescott area as a result of the automobile. It took eight years for the local citizens, under the direction of Harry Head, Francis Viele, and Moses Hazeltine, to raise the $200,000 needed to build the Hassayampa, plus another $75,000 for its lavish furnishings (below, 1930s). Henry Charles Trost, an associate of Luis Sullivan and Frank Lloyd Wright, was the architect.

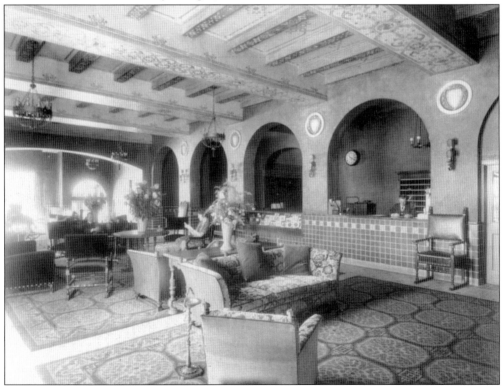

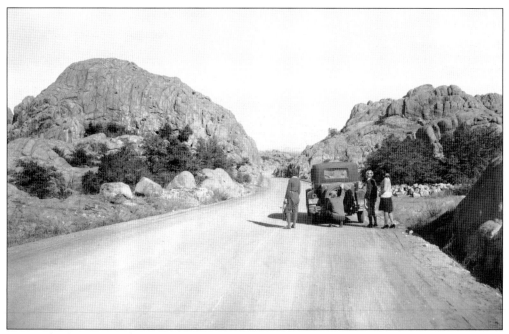

As new highways were built, more and more tourists came to Prescott, bringing a boost to the local economy. Moreover when the new Black Canyon Highway was completed in 1952—bringing Phoenix 18 miles closer than via the previous winding route through Kirkland, Congress, and Wickenburg—the population of Prescott was boosted as well. From the turn of the century until the 1950s, the population grew from about 3,500 to 6,764. From the 1950s to the 1960s, the population gained another 6,097, an increase of over 90 percent.

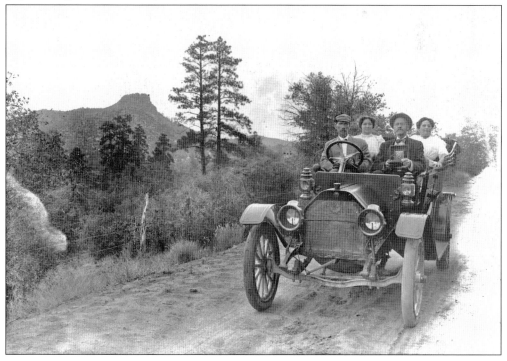

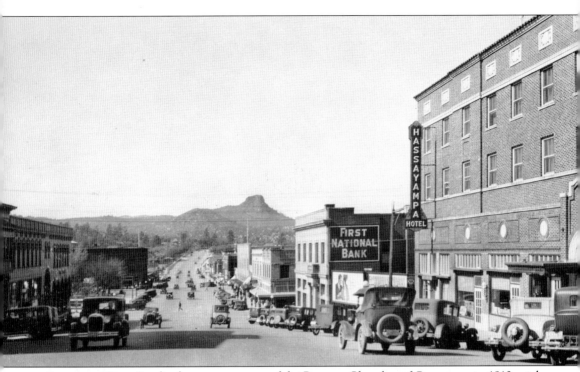

Ever since Grace Sparkes became secretary of the Prescott Chamber of Commerce in 1910, a job she held the job for 33 years, Prescott has been promoted (quoting Nancy Burgess and Richard Williams in A *Photographic Tour of 1916 Prescott, Arizona*) as "a perfect place to visit, a wonderful place to live, a mecca for health-seekers, and a place with a great potential for farming, mining and ranching. In 1914, Grace Sparkes . . . started publishing *Yavapai Magazine*, an illustrated periodical designed to 'boost' Yavapai County and promote its assets in the best light possible. Articles were written by and about local businessmen and women, businesses and industries, including lots of tourist, statistical and economic information."

Nine

TOURISM AND THE
POPULATION BOOM

The mile-high elevation and the dry, high desert surrounding park-like Prescott account for its salubrious climate. The Sierra Prietas, the Bradshaws, Mount Union, Granite Mountain, and Mingus Mountain, all enveloping Prescott, account for its spectacular scenery. From the slopes of the mountain flow the historic Hassayampa and Lynx Creeks, where the Walker party first discovered gold. Northwest is the Williamson Valley, the route of the first pioneers coming to Prescott. Northeast is Chino Valley, home of the first Fort Whipple. Look anywhere around town and there is always something that reflects Prescott's rich history. It is no wonder that it has seen such phenomenal growth.

Early on, Prescott became a prime destination for health enthusiasts. Since 1881, public hospital facilities have been readily available. Since the turn of century, a number of sanitariums have sprung up in town as well. Since 1959, Fort Whipple has been famous as a VA hospital for its treatment of tuberculosis.

Because of its healthy climate and facilities, Prescott also has become a desirable place to retire. Founded in 1909, the Arizona Pioneers' Home, the only state-supported retirement facility for early residents, led the way. Prescott's schools, from the small private school organized in 1864 to Prescott's three colleges, Embry-Riddle Aeronautical University, Prescott College, and Yavapai Community College (established in 1966), are also a big draw for the community. Its churches and social organizations have made Prescott an attractive place for families as well.

Add to that the variety of diversions and recreations available and it's easy to understand why the town has recently become so popular. Museums, galleries, concerts, and performances abound. But nothing speaks so grandly as Prescott's ample natural resources: 125 million acres of public access, 116,000 acres of wilderness, and 450 miles of back-country trails.

Yet with all its growth, Prescott still retains its small-town charm. In 1985, it was proclaimed by *Arizona Highways* as "Everybody's Hometown." In that same year, Prescott was chosen as an "All-American City." Also in the 1980s, *Money Magazine* designated Prescott as the best place to retire. Just this year, in 2006, *50 Fabulous Places to Retire in America* and *The 100 Best Art Towns in America* highlight Prescott as one of the best. *True West* magazine named Prescott as one of America's top 10 western towns, touting its Frontier Days and Rodeo as the "Top Western Event of the Year."

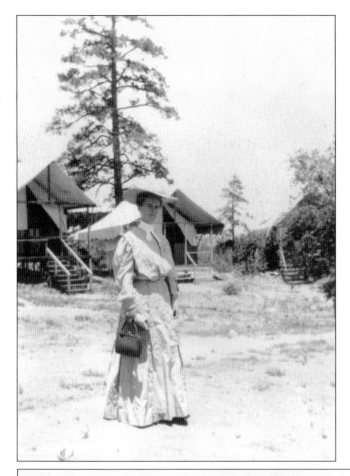

Probably the most respected of the health resorts to come to Prescott was Dr. John Finn's facility, Pamsetgaaf, (an acronym for "Pure Air–Mountain Sunshine-Equable Temperature-Good Accommodations-Abundant Food"), which he and his wife operated from 1903 to 1945. The Finn Sanitarium buildings, pictured here, on Willow Street off West Gurley, housed such well-known patients as Walter Winchell, Cleveland Amory (editor of the *Courier*), and Lila Lee (silent-screen actress).

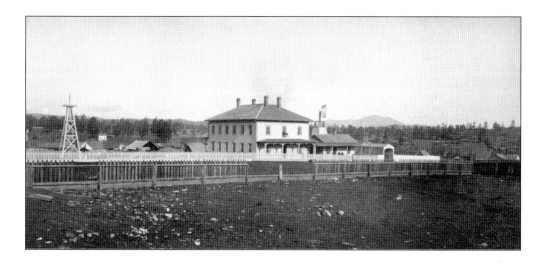

The first hospital in Prescott was the Sisters of Saint Joseph on North Marina Street, near Willis Street (above). In 1893, Fr. Alfred Quetu brought the Sisters of Mercy to town to take over nursing duties. In 1898, the hospital changed its name to Mercy Hospital and moved to Grove Avenue (below), on land donated by Frank Murphy. Only one wing of that building survives today, as the main hospital burned down in 1940. In 1943, the former Jefferson Elementary School Building on the corner of Marina and Leroux Streets was converted into a community hospital. In 1964, the new Yavapai Community Hospital was built on Willow Creek Road.

MERCY HOSPITAL. PRESCOTT, ARIZ.

In 1909, Frank Murphy donated land for the retirement facility known as the Pioneers' Home (above, 1920s). In 1916, a wing was added to the Pioneers' Home for the exclusive use of women pioneers in Arizona. The Arizona Pioneers' Home is the only state-supported retirement facility for early residents of the state of Arizona.

In 1864, Mary Catherine Leib, Harriet Turner, and Fannie Cave Stephens organized a private school in Prescott, with an appropriation from the territorial legislature of $250. In 1869, Samuel Rogers started teaching at the first public school in Yavapai County, using books he brought with him and those he borrowed from the territorial library. In 1867, Rogers built a one-room log schoolhouse, pictured here, on the east bank of Granite Creek.

Rogers's building was used until 1876, when the Prescott Free Academy opened on the first floor of the Old Capitol Building on the south side of East Gurley Street. In 1903, the Prescott Free Academy, the Arizona territory's first graded school, was replaced by the Washington School, pictured here, built across the street on the north side of Gurley Street. After that, the Old Capitol Building on East Gurley Street became the first high school in Prescott.

In 1909, the Lincoln Elementary School was built.

In 1916, the Miller Valley Elementary School was constructed (above). Originally children in Miller Valley went to school at the West Prescott Elementary School, built in 1878 (below).

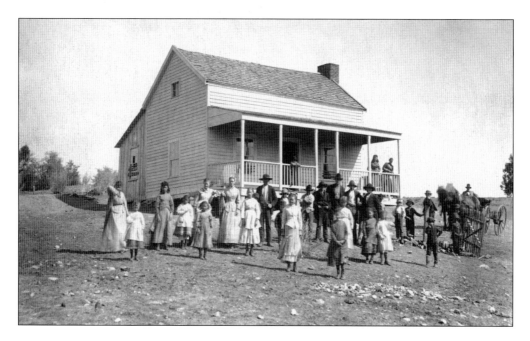

Prescott's first library was the reference library of over 300 books brought to Prescott in 1864 by Secretary of State Richard C. McCormick for use by government officials in the new Arizona territory. In 1899, the Woman's Club of Prescott, also known as the Monday Club, led by Julie K. Goldwater, set out to establish a free library in Prescott, garnering matching funds from the Andrew Carnegie Foundation for the construction of a library building on the corner of the courthouse Plaza. After all the books were destroyed in the great fire of 1900, however, the Prescott Public Free Library, also known as the Carnegie Library, ended up being built on the southwest corner of Gurley and Marina Streets in 1903.

In 1880, the Baptists built the Lone Star Baptist Church, pictured here around the 1880s, on Grove Avenue, moving to South Cortez Street in 1884 and to the corner of Goodwin and Marina Streets in 1923.

In 1881, the Congregationalists (above, c. the 1890s) built the First Congregational Church on the Willis and Alarcon block, moving to the corner of Gurley and Alarcon Streets in 1905 (below, c. the 1900s).

In 1891, the Methodist Church on North Marina (above, c. 1895) was moved down the street where the congregation worshipped until the new Methodist church was built on the corner of Summit and West Gurley Streets in 1935 (below, 1956).

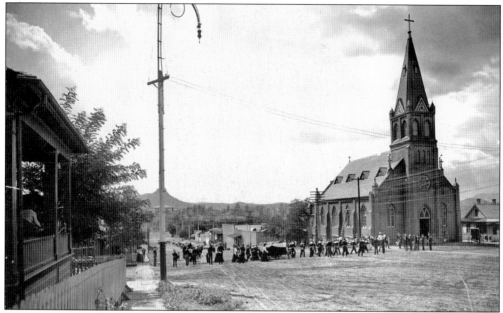

Also in 1891, the Catholics built Sacred Heart Church (above, pictured during a funeral, *c.* 1904) on Willis Street, on the site of the former St. Joseph's Academy, next door to the Saint Joseph Hospital. Melissa Ruffner states in *Prescott: A Pictorial History*, "The first services were held there on Sunday, February 17, 1895, with Father Alfred Quetu [who served the Catholic community from 1889 until 1908] officiating. The church is still standing, although the steeple was removed because it was hit by lightning several times." In 1892, the Episcopalians built St. Luke's church (below) on the corner of Marina and Union Streets.

The Masons first met in the governor's mansion in 1865 before moving to their first quarters on the second floor of the Little Diana Saloon in 1867. They later moved to their new Masonic Temple on the second floor of the M. Goldwater and Brothers Store in 1879. The Independent Order of Odd Fellows was founded in 1868 with the first meeting also taking place in the governor's mansion. Since most of the Odd Fellows were also Masons, they shared quarters until 1886 when the Odd Fellows built a hall on the corner of Cortez and Goodwin Streets (above, 1890s). The group remained there until building a new hall in the middle of the Goodwin block in 1901. The Masons constructed their newest building on North Cortez Street in 1907 (below, laying the cornerstone).

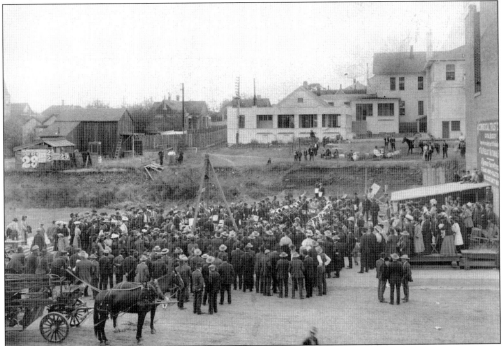

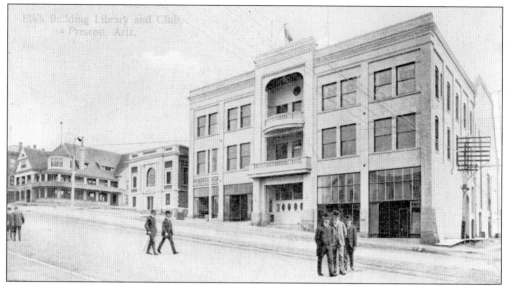

When the Elks constructed a new lodge building on Gurley Street in 1906 (above, *c.* 1910), they brought a state-of-the-art theater with a professional stage and excellent acoustics to Prescott (below, *c.* 1928). States D. E. Born in *Stories of Early Prescott*:

> The lodge itself was housed on the top floor and space was provided on either side of the theater entrance from small shops. The theater was known initially as The Elks Opera House and later as The Elks Theatre. As about the only entertainment in a town of 4,000 it drew good crowds almost every night of the week to watch plays, light opera, minstrel shows and vaudeville acts performed by both local groups and traveling companies.

Remodeled in 1943, the Elks Theater is still in use today.

Among art offerings in Prescott are those produced by Yavapai College, the Mountain Artists Guild, and the Southwest Artists Association, as well as the famous Phippen Museum of Western Art. The Phippen Museum, which opened as a gallery in 1981, houses works of local artist George Phippen, pictured here in his studio in the 1960s. The George Phippen Invitation Western Art Show is held every Memorial Day weekend on the Courthouse Plaza in Prescott.

As far as the music scene is concerned, the Yavapai Symphony Association, the Friends in Concert, and Yavapai College offer several series of concerts. Music festivals are also scheduled regularly at Watson Lake Park, pictured here, three miles north of Prescott.

Three public sculptures are also exhibited in the Plaza. One is *Roughrider*, pictured here at its July 3, 1907, dedication, sculpted by Solon Broglum in 1907 as a memorial to those who fought and died in the Spanish-American War, including Prescott's famous William Owen (Buckey) O'Neill. *Cowboy Resting*, based on a model by Solon Borglum, was unveiled in 1990 also in the Plaza. And the other is a memorial dedicated to local veterans from World War I and II, Korea, Vietnam, and the Persian Gulf who died in service to their country, created by local artist Neil Logan in 1989. Elsewhere in town is *Early Settlers* by Bill Nedeker on Memorial Island at the intersection of Sheldon and East Gurley Streets, *First Rodeo* by Richard Terry in front of city hall, and *Silver Tornado* by Natalie Krol in front of the Yavapai Regional Medical Center.

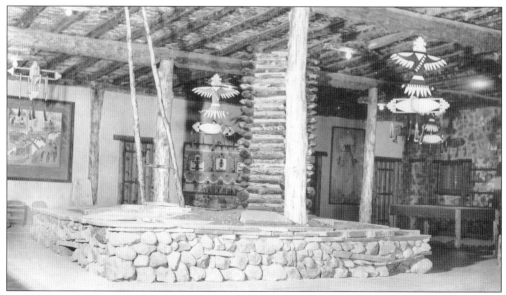

Local history is the focus of the Smoki Museum, pictured here *c.* 1934, featuring Indian arts and crafts.

Ten

THE SHARLOT
HALL MUSEUM

One of Arizona's most remarkable women founded what has become one of Arizona's most remarkable museums. Sharlot M. Hall administered the initial growth of the Mansion Museum, so named for the territorial governor's mansion, built in 1864. Sharlot herself renovated and opened the 1864 structure to the public, resided in part of it, and personally welcomed visitors. For 15 years until her death in 1943, Sharlot, a poet, iconoclast, and historian, served as the institution's first director, overseeing the 1930s construction of the stone building that now bears her name and that today hosts history and anthropology exhibits.

Now in its 78th year, the Sharlot Hall Museum is an accredited institution that occupies a full city block two blocks west of Courthouse Plaza and contains several historic buildings, graced by heritage gardens and outdoor sculptures. In 2004, the Fort Whipple Museum, a branch of the Sharlot Hall Museum, opened in Prescott. In 2005, the Walnut Creek Research Center, a campus in the forest one hour north of town, began hosting the museum's archaeology field school. For the downtown museum, a new auditorium and new gardens are also planned.

From June through October, the Sharlot Hall Museum is the venue for five major festivals. The Folk Arts Fair, in June, features demonstrations of the old ways of "making do," from chair caning to candle dipping to blacksmithing. The Prescott Indian Art Market, in July, showcases the traditional and contemporary art forms of over 80 artists; native dancing and music are also part of the weekend. The Arizona Cowboy Poets Gathering, in August, is one of the most respected such gatherings in the West, known for its adherence to traditional poems and songs of the working cowboy. The Prescott Book Festival, in September, features over 40 book vendors and several guest authors. The first weekend in October holds the concluding festival of the season, the Folk Music Festival, featuring traditional folk, blues, and bluegrass tunes from over 100 musicians.

Research services through the museum archives and library are an important part of the museum's mission. Many researchers benefit from the breadth and depth of the website, www.sharlot.org, particularly in regard to historic maps. Other unique public services of the Sharlot Hall Museum include the Blue Rose Theater, which performs historic plays indoors and at the amphitheater, and the Living History program, which makes scheduled presentations of authentic pioneer life. Sharlot Hall's museum has become the civic center she envisioned, with community forums, three lecture series, and exhibits ranging from fine art to anthropology.

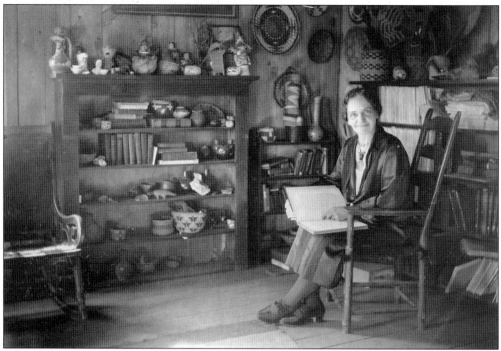

Sharlot M. Hall, museum founder, began welcoming guests in 1928. By that year, she had already established herself as an historian, author, poet, and preservationist. Sharlot's poem "Arizona," written in 1906, played an important role in establishing statehood in 1912.

On a tree-shaded slope rising from Granite Creek, the four-acre campus of the Sharlot Hall Museum is anchored by two historic buildings: the Fremont House (left), home of John Charles Fremont that was relocated from downtown, and the territorial governor's mansion, built on-site in the fall of 1864.

The grand Victorian structure known as the Bashford House, built in 1877, was relocated to the museum campus in 1974. Owned by one of the first successful merchants and bankers in Prescott, the Bashford House now hosts the Museum Store, which carries an inventory of turn-of-the-century goods.

The fifth territorial governor of Arizona, John C. Fremont, had this home from 1878 through 1881. The landscaped museum campus has an arboretum, a panoply of gardens, and a peaceful park to be enjoyed in an historical setting two blocks west of downtown Prescott.

The historic buildings of the Sharlot Hall Museum campus host many exhibits. One gallery explores the history of the military in the Arizona Territory from 1863 to 1912. Authentic cavalry gear, Apache scouts, and life on the post are a few of the stories. Also part of the museum system is the Fort Whipple Museum, three miles north of downtown.

History comes to life at the Sharlot Hall Museum with many events scheduled on summer Saturdays. Children of all ages learn the old ways of doing things, and of "making do." The cook fire is always popular, with a pot of pioneer stew ready to warm the hungry visitor.

Youngsters in traditional pioneer costumes enjoy the "Arizona History Adventure" at the Sharlot Hall Museum. The museum offers several programs for children, including Tenderfoot Theater, school tours, and the annual Folk Arts Fair that features candle-dipping, tinsmithing, and old-time games.

The first weekend in October is the time for the Folk Music Festival at the Sharlot Hall Museum. For two days, visitors can enjoy all manner of traditional music around the autumn-tinged campus. Fiddlers and banjo players perform everything from gospel to bluegrass to good-time tunes.

ACROSS AMERICA, PEOPLE ARE DISCOVERING SOMETHING WONDERFUL. *THEIR HERITAGE.*

Arcadia Publishing is the leading local history publisher in the United States. With more than 3,000 titles in print and hundreds of new titles released every year, Arcadia has extensive specialized experience chronicling the history of communities and celebrating America's hidden stories, bringing to life the people, places, and events from the past. To discover the history of other communities across the nation, please visit:

www.arcadiapublishing.com

Customized search tools allow you to find regional history books about the town where you grew up, the cities where your friends and family live, the town where your parents met, or even that retirement spot you've been dreaming about.